DIGITAL GRAPHICS

ROCKPORT
PUBLISHERS

Rockport Publishers, Inc.
Rockport, Massachusetts

First published in the United States of America by:
Rockport Publishers, Inc.
146 Granite Street
Rockport, Massachusetts 01966
Telephone: (508) 546-9590
Fax: (508) 546-7141

Distributed to the trade by:
Consortium Book Sales & Distribution, Inc.
1045 Westgate Drive
Saint Paul, MN 55114
(612) 221-9035
(800) 283-3572

Other Distribution by:
Rockport Publishers, Inc.
Rockport, Massachusetts 01966

Cover Contributions:
(Clockwise from top left)
Rumrill-Hoyt, R/GA Digital Studios
Jan Ruby-Baird
Kerry Gavin
Steve Campbell
Multi Dimensional Images
(center) Schell Mullaney

ISBN 1-56496-336-5

Printed in Hong Kong

Introduction

When image scanners, computers, and graphics-quality printers migrated from service bureaus to the desktop, it empowered the graphic designer to do many things that could not be done before. Better yet, the software that came with the desktop computers automated many tasks—like cutting friskets and rubylith—that traditionally took a lot of time and expense. With computers, less time is spent finishing a project by hand, so more time can be spent perfecting it.

Desktop publishing systems help produce exciting, complex artwork. *Design Library: Digital Graphics* features fantastic pieces that began with image scans or even blank screens. Designers use many tools to achieve these final designs—image editing software, digitizing tablets, illustration and painting software, even digital cameras—but they all have in common the goal of creating fantastic graphics. Flip through the pages of this book, and you will see that they all succeed.

Solving the Quintic

with Mathematica

The impossibility of solving general quintics in radicals

The general solution of the quadratic equation was found more than 4000 years ago. The solution of the cubic and quartic—found in the 1500s—was a major result of Renaissance mathematics. Mathematicians struggled for centuries to find formulas for the solutions of equations of higher degree, but despite the efforts of Euler, Bézout, Malfatti, Lagrange, and others, no general solutions were found. Finally, Ruffini (1799) and Abel (1826) showed that the solution of the general quintic cannot be written as a finite formula involving only the four arithmetic operations and the extraction of roots. By 1832 Galois had developed the theory of Galois groups and described exactly when a polynomial equation is solvable.

There are polynomials of degree greater than four which do not factor over the rationals, but that can still be solved in radicals. An example is the quintic $x^5 + 20x + 32 = 0$, one of its roots is:

There are polynomials of degree greater than four which do not factor over the rationals, but that can still be solved in radicals.

Tschirnhaus' transformation

In 1683 Tschirnhaus published *Method of Eliminating All Intermediate Terms from a Given Equation*. Although the title exaggerated, Tschirnhaus' paper was the most important idea for the solution of algebraic equations in about 200 years.

Tschirnhaus' transformation reduces the nth degree polynomial equation:

$$a_n x^n + a_{n-1} x^{n-1} + \cdots + a_1 x + a_0 = 0$$

to one with up to three fewer terms:

by transforming the roots as follows:

where the y_i can be expressed in radicals in terms of the a_j. Thus every quintic can be transformed into one of the form:

$$x^5 + b_1 x + b_0 = 0$$

Klein's approach to the quintic

In 1877 Klein published *Lectures on the Icosahedron and the Solution of Equations of the Fifth Degree*. In this remarkable book and in a later article Klein gave a complete solution of the quintic.

He used a Tschirnhaus transformation to reduce the general quintic to the form:

$$x^5 + 5ax^2 + 5bx + c = 0$$

Hypergeometric functions

The generalized hypergeometric function in Mathematica `HypergeometricPFQ[{a_1, a_2, ...}, {b_1, b_2, ...}, z]` is defined by the following power series:

Theta functions

Jacobi and Abel first studied theta functions in 1827. They are named $\theta_1(z,q), \theta_2(z,q), \theta_3(z,q), \theta_4(z,q)$ in Mathematica. Their series definition is:

The elliptic modular function $\phi(\tau)$ is defined by:

Solutions based on series

Johann Lambert (1757) seems to have been the first person to have the idea of using series to solve a polynomial equation. In the next 150 years similar ideas were raised independently by Leonard Euler (1779), Pafnuti Chebyshev (1838), and Gotthold Eisenstein (1844), among others.

We first illustrate the idea with the quadratic and then go on to the quintic.

Solutions based on differential equations

Cockle (1863) and Harley (1862) developed a method for solving algebraic equations based on differential equations.

Equations of higher degree

Some of the ideas described here can be generalized to equations of higher degree. The basic ideas for solving the sextic using Klein's approach to the quintic were worked out around 1900. For algebraic equations beyond the sextic, the roots can be expressed in terms of hypergeometric functions in several variables or in terms of Siegel modular functions.

Steps to the Quintic

Quadratic equation

Cubic equation

Quartic equation

Quintic equation

An example

The program

Columns
Designer Sergio Spada
Client Self-promotion
Software Adobe Photoshop
Hardware Macintosh Quadra 950

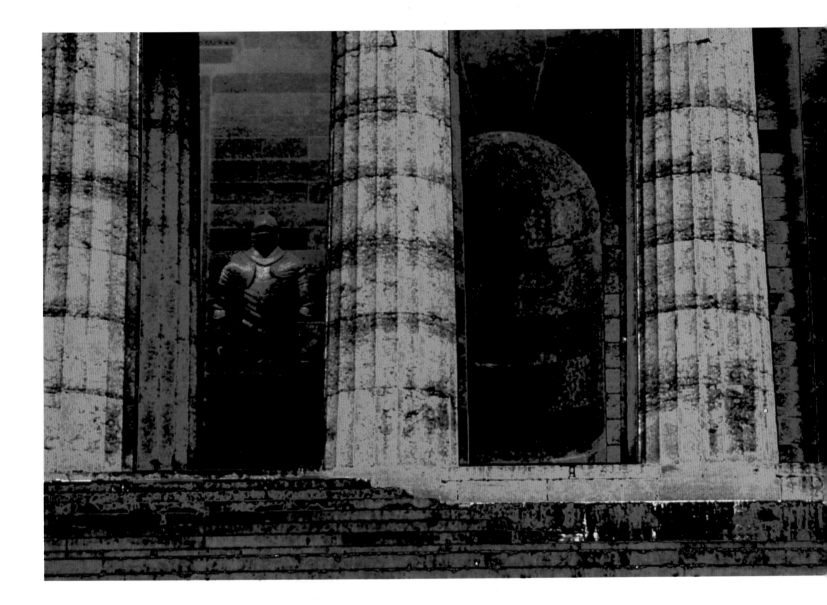

Computer Software Poster
Design Firm Wolfram Research Publications Department
Art Director John Bonadies
Designer Jennifer Lofgren
Client Wolfram Research, Inc.
Software Mathematica, QuarkXPress, Adobe Illustrator, Adobe Photoshop
Hardware Macintosh Quadra 950

Graphics and the mathematical equation typeset were created in Mathematica. Layout was completed in QuarkXPress and the final image was printed with a combination of 6-color, metallic, and black and metallic mix.

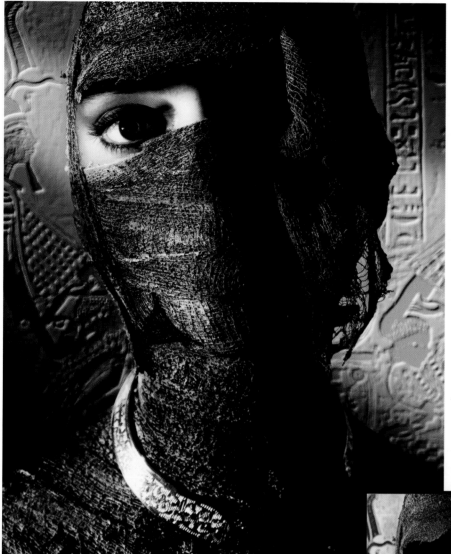

Two photographs were used for this illustration with a 4 x 5-inch camera and Kodak 100-speed film. The first picture depicted the mummy and backdrop, created by wrapping a department-store mannequin in gauze and airbrushing it to make it look old. The right side was painted flat black to increase the dramatic effect of the shadow without having to rely too much on exposure. Where the eye would be placed in the final composition was a piece of black velvet, to give a clean edge with sharp contrast for when the two images were merged. The final touch was a light dusting of whole wheat flour to add that extra touch of decay. The background was a copy of some hieroglyphs taken from a King Tut book. The second photo was of the eye, which was lit the same way as the mummy.

The two pictures were processed on 11 x 17-inch art paper, then scanned into Photoshop. The eye had to be positioned in the exact spot on the illustration to make things look normal. Touching up the edges where the mummy met the eye was done with an electronic airbrush supplied by Photoshop. With several of the tools in Photoshop, the artist was able to make the background look more like an eroded tomb wall. Then the lighting effect of a beam crossing the frame was made with the Airbrush tool.

Project The Mummy
Design Firm Red Rockett
Illustrator Adam Murguia
Hardware Power Mac 8100/80, Hewlett-Packard ScanJet 3C flatbed scanner
Software Adobe Photoshop and Illustrator, Hewlett-Packard DeskScan

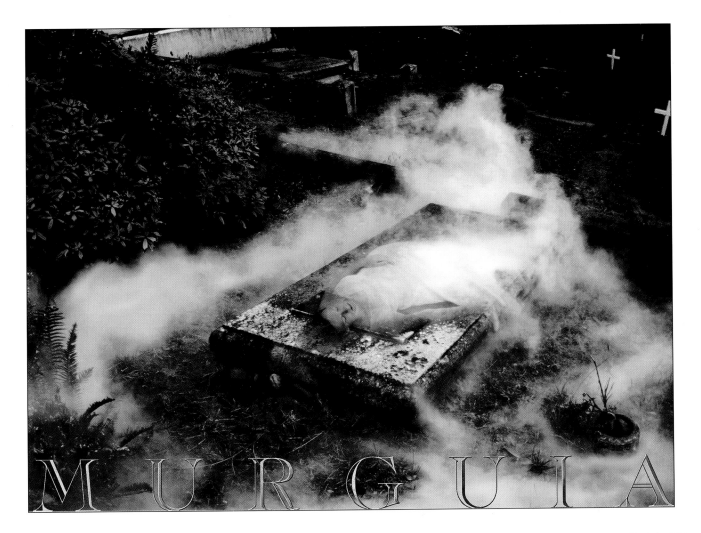

Project The Ghost
Design Firm Red Rockett
Illustrator Adam Murguia
Hardware Power Mac 8100/80, Hewlett-Packard ScanJet 3C Flatbed Scanner
Software Adobe Photoshop and Illustrator; Hewlett-Packard DeskScan

Two photographs were necessary: one of a woman and a grave; one with the grave alone. The fog was partly done with a CO_2 fire extinguisher sprayed seconds before clicking the shutter on the camera. In the final image, the model's dress looks as if it is draped over the tombstone. Photoshop made it possible to make the fog and model look as if it is they were one and the same. The artist's last name in the bottom of the picture was also entirely composed in Photoshop with the letters cast as a reverse of the image behind it, then adding highlights and shadows.

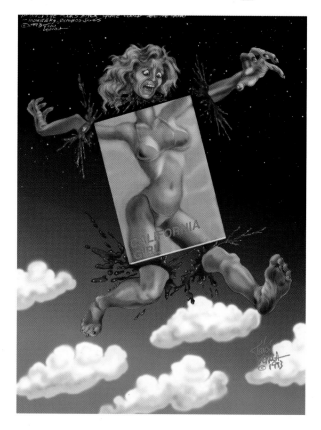

If Only the Folks Back Home
Technique Wet-on-Wet, Virtual Trace Paper, Digital Airbrush
Illustrator Trici Venola

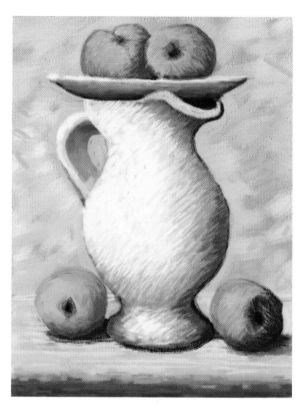

Still Life with Pitcher and Apples
Technique Wet-on-Wet
Illustrator Dennis Orlando

Poetic Offering
Technique: Wet-on-Wet, Virtual Masking, Virtual Trace Paper, Painting Words
Illustrator Mario Henri Chakkour

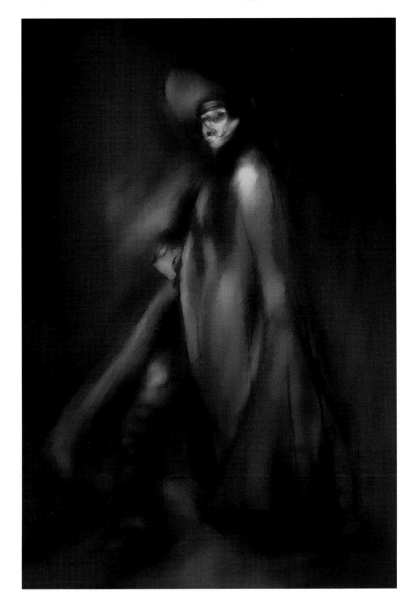

Portrait of a Lady
Technique Wet-on-Wet
Illustrator Dewey Reid for Colossal Pictures

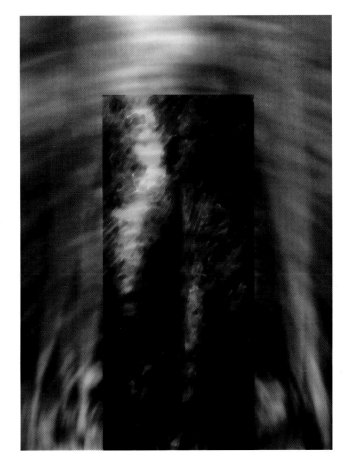

Night Visions 1
Technique Wet-on-Wet, Virtual Masking
Illustrator Karin Schminke

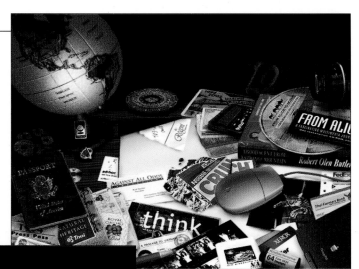

Passage to Vietnam from Rick Smolan (who also authored *From Alice to Ocean*) is perhaps the most intelligent and beautifully designed CD-ROM. A culmination of eighteen months of work by seventy photographers, this award-winning CD-ROM shows an intimate portrait of the people, culture and country of contemporary Vietnam in its more than four hundred photographs. Accompanying the photographs are video sessions with photographers; video and audio clips that explain how and why certain photos were taken; and visits to virtual galleries that acquaint you in detail with four photographers' work.

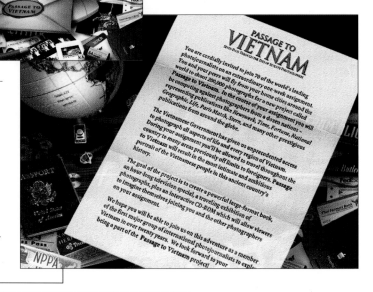

The interface makes use of ad·hoc interactive's "Quebe," a cube-shaped icon that rotates with mouse clicks, which resides in the lower right corner of the screen. Each side has a function that carries the user to different topics, a map, the help screen, or more tools.

During the exploration of *Passage to Vietnam*, the Quebe opens to reveal different items such as a formal invitation for the user to enter a virtual gallery of photographs. At one point Rick Smolan, the project's creator, appears from the top of the Quebe to explain the navigational aspects of the Quebe and the CD-ROM's interface.

In all aspects of the interface, the designers find ways to capture the user's attention, from beautiful photography to a clever video sequence of the publisher walking out onto a precarious monkey bridge to introduce the next topic.

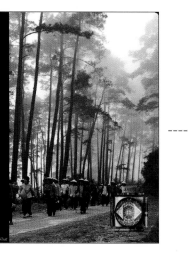

DREAMS OF A
GENTLE LAND
by Pico Iyer

Like most tropical countries, Vietnam gets up with the light, and one of the greatest pleasures you can find there is to go outside at six in the morning and see the whole town out stretching its limbs, playing badminton or soccer in the streets, ghosting its way through *tai chi* motions.

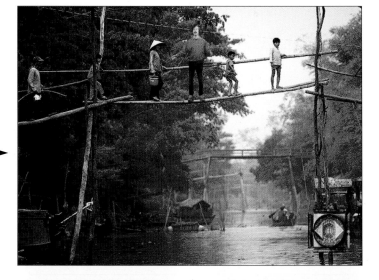

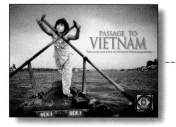

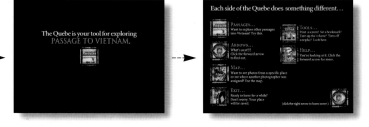

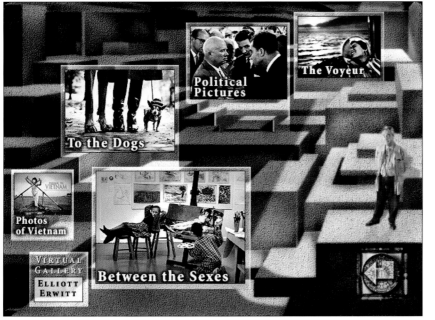

Project *Passage to Vietnam*
Client Against All Odds Productions
Design Firm ad·hoc Interactive Inc.
Designers Aaron Singer, Megan Wheeler
Illustrator Megan Wheeler
Photographers 70 international photographers
Programmer Shawn McKee
Authoring Program Macromedia Director
Platform Mac/Windows/Windows 95

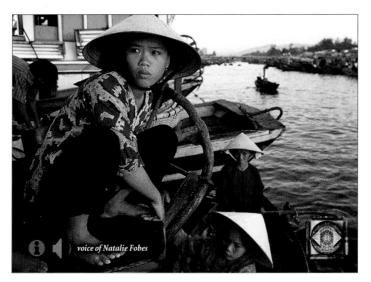

voice of Natalie Fobes

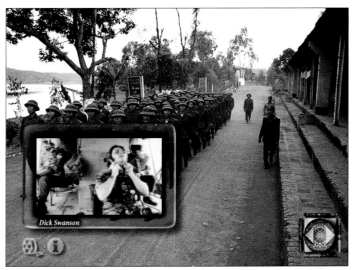

Dick Swanson

 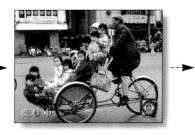 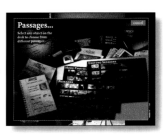

11

ROUGH

A Publication of the Dallas Society of Visual Communications · November 1996 · Volume Four · Issue Number Three

Hey, Phil...Read This:

THE JUMBO-TYPE, CLIENT-FRIENDLY TABLE OF CONTENTS

ONE FOR THE BOOKS

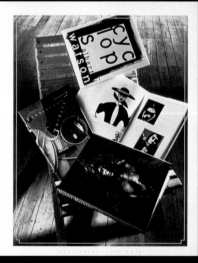

CYCLOP Sharon Watson

Country Western

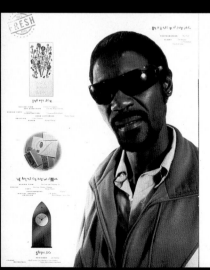

FRESH

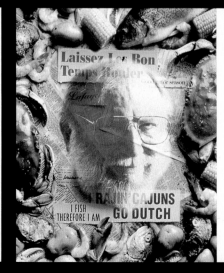

Laissez Le Bon Temps Rouler

RAJIN' CAJUNS GO DUTCH

I FISH THEREFORE I AM

DUTCH TREAT

DUTCH REPLY DUTCH REPLY

Here in his own words is the story of how he got started in the business, who he left, what makes his career so successful and a trail of memories that reads like the Who's Who of Dallas Advertising. He's the Commander of the Art Marines... a Big Fish in the Little Pond of Lafayette (and, Dutch, if you're listening, an equally big fish in the pond called Dallas)... The Flying Dutchman: Dutch Boyler. What a treat to get to know him.

Down in, what some might call the middle-of-nowhere, in the little town of Lafayette, Louisiana, the University of Southwestern Louisiana cranks out here outstanding design graduates per capita than almost any all-purpose university in the nation. And, as the recipient of most of that talent, the Dallas advertising community has one man to thank for it.

Trade Magazine
Design Firm Peterson & Company
Art Directors Scott Ray
Designers B. Peterson. J. Wilson. D. Eliason. N.T. Pham. S. Ray
Client Dallas Society of Visual Communications
Software QuarkXPress. Adobe Photoshop
Hardware Macintosh 7100

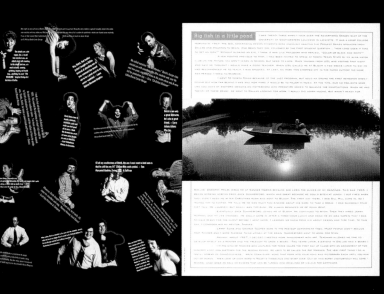

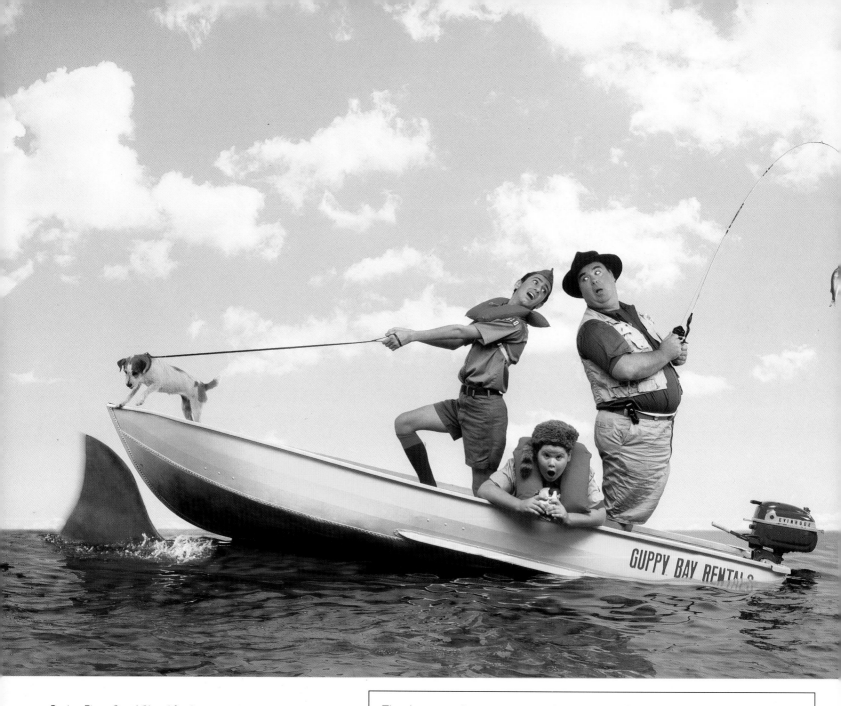

Design Firm David Blattel Studios
Art Director John Cecconi
Computer Artist Dennis Dunbar, Phaedrus Pro
Photographer David Blattel
Stylist Kim Pretti
Hardware Macintosh
Software Adobe Photoshop, Adobe Illustrator
Client Self-Promotion

The design goal was to create a humorous self-promotion with production value. The image was shot in-studio, using an artificial bay with real water. The boy was photographed holding an empty leash, and the dog, the background, and the splash around the shark fin were later added by computer. Background was also added at a later time and was an existing stock image.

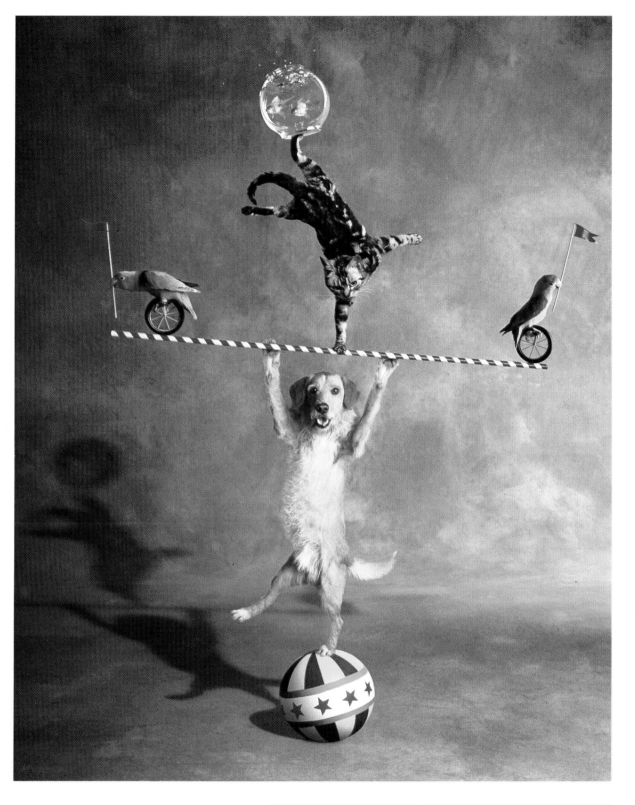

Design Firm Schell Mullaney
2-D Image Processing R/GA Print
Digital Design R/GA Print
Photographer Howard Berman
Hardware Macintosh
Software Adobe Photoshop
Client Computer Associates

For this playful advertisement, artists digitally integrated individual photographs of animals to create a circus act performed by household pets. Computer effects include the digitally generated shadow that helps add realism to this difficult balance of elements.

Design Firm David Blattel Studios
Art Director David Blattel
Computer Artist Dennis Dunbar,
 Phaedrus Pro
Photographer David Blattel
Stylist Alexandra Jordan
Hardware Macintosh
Software Adobe Photoshop,
 Adobe Illustrator
Client Self-Promotion

The Miata automobile was photographed parked on a winding road, using a zoom lens (zoomed during exposure) to create the feeling of motion. The passengers were photographed later, and their images were dropped in digitally by computer, then blurred to match the car. The "Road Closed" sign was a miniature that was also shot separately and added by computer.

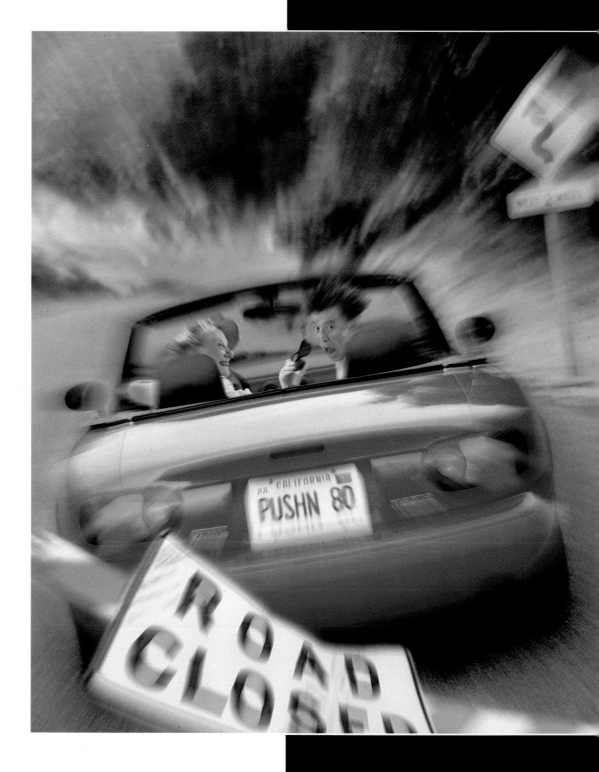

Design Firm J. Walter Thompson.
 R/GA Digital Studios
Digital Design R/GA Print
2-D, 3-D Animation R/GA Print
Photographer Stock Image
Hardware Macintosh, Silicon Graphics
 workstation
Software Imrender. Adobe Photoshop
Client Kodak

The design firm digitally bent the world's most famous skyscraper in this advertisement. Visual effects include three-dimensional image warping and digital retouching to correct color and to add light.

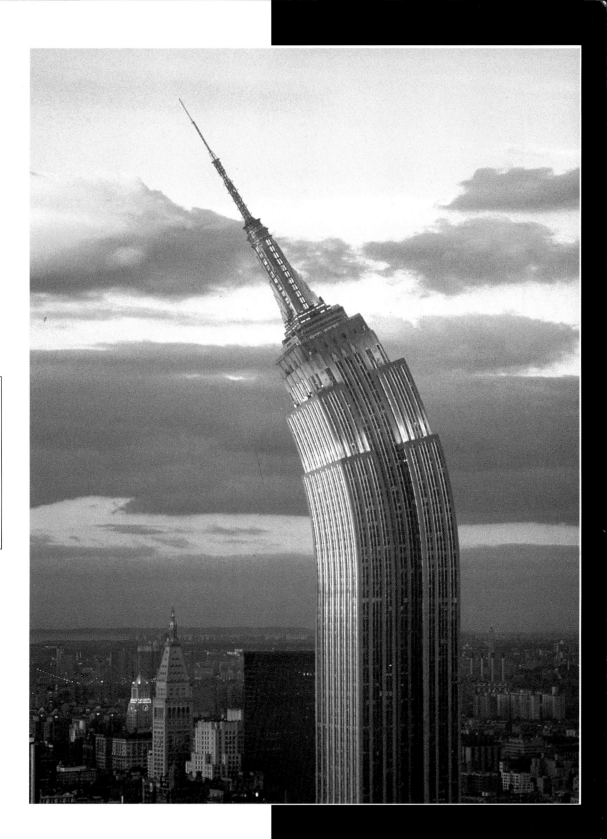

Sales Conference Logos
Design Firm Hornall Anderson Design Works
Art Director Jack Anderson
Designers Jack Anderson, Cliff Chung, Scott Eggers,
David Bates, Leo Raymundo
Client Food Services of America
Software Aldus FreeHand
Hardware Power Macintosh 8100

The star in this design created in FreeHand
is a direct reference to the FSA logo and is
made up of loose "energy bursts."

Summer Exhibit Logo
Design Firm Rapp Collins Communications
All Design Bruce Edwards
Client Minnesota Zoo
Software Adobe Illustrator
Hardware Macintosh FX

This design began as rough sketches that were then
combined with five bug images created in
Illustrator. The designer spent forty hours reducing,
enlarging, and placing bugs until the proportions
were correct.

Tree Care Company Logo
Design Firm Watt. Roop & Co.
All Design Gregory Oznowich
Client Morningstar Tree Service. Inc.
Software Aldus FreeHand
Hardware Macintosh Quadra 950

The logo was designed in FreeHand. then exported and saved as both TIFF and EPS files for applications on letterhead. trucks. and forms.

Environmental Consulting Firm Logo
Design Firm Hornall Anderson Design Works
Art Director Jack Anderson
Designers Jack Anderson. Julie Lock. Lian Ng
Client Shapiro & Associates. Inc.
Software Aldus FreeHand
Hardware Power Macintosh 8100

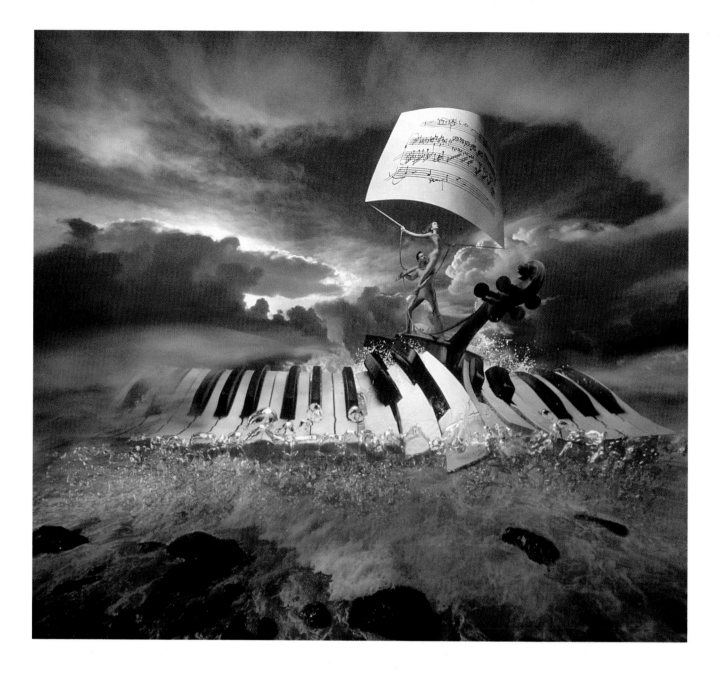

Design Firm Rumrill-Hoyt, R/GA Digital Studios
Digital Design R/GA Print
2-D, 3-D Animation R/GA Print
Photographer Ryszard Horowitz
Hardware Macintosh, Silicon Graphics workstation
Software Imrender, Adobe Photoshop
Client Kodak

This image demonstrates the collaborative imaging process. Three-dimensional imaging of the piano keys, digital retouching, and layer composition were used to develop the piece.

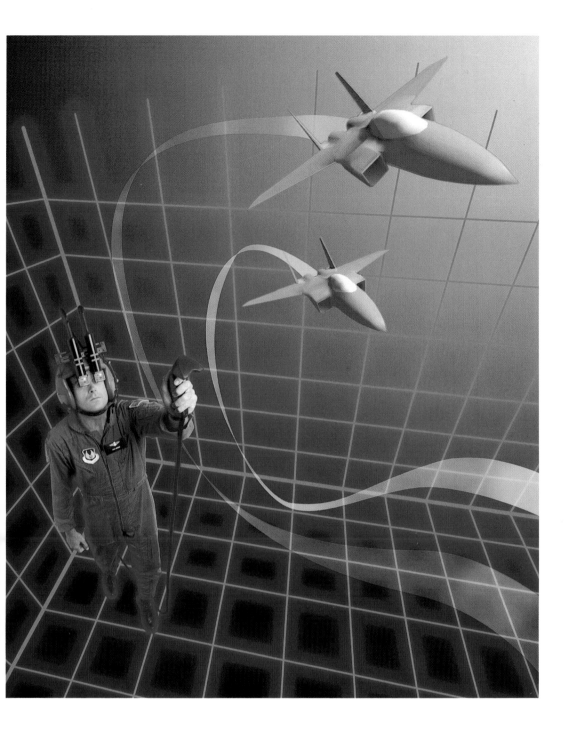

Design Firm Research Communications
 Center
All Design Brian Watkins
Hardware Quadra 950. Leafscan 45
Software Adobe Photoshop.
 Macromedia Swivel 3-D
Client UDRI

The design goal was to emphasize the expanding interaction between humans and technology. specifically in the areas of simulation and pilot training. The photograph of the pilot was scanned into the computer. and a neutral gray gradient was laid down as the background. The pilot was then "pasted" on the mask to separate him from the background. The plane was adjusted in Macromedia's Swivel 3-D for scale. color. lighting. and positioning. Ribbons were drawn using the pen tool in Photoshop.

Bad Mojo™, produced by Pulse Entertainment, is an example of a seamless navigational environment. The interface requires the user to interact with a clue-filled visual environment featuring a roach as its central character.

The user controls the action of the roach with four keyboard commands (left, right, forward and backward). As the roach scurries across hidden hotspots, different actions are set in motion. For example, crawling across an electrical cord turns on a vacuum; scuttling too near an apparently dead rat's mouth results in losing a roach-life (opposite page).

The designers have created a set of linear experiences for the user to follow by using obstacles—such as water, blood, and rat poison—to keep the user heading in the right direction. An added visual cue is the appearance of a "guide roach" that appears, shows which way to go, and then disappears.

Users begins their journey by exiting a drain that leads to the underside of a furnace, complete with animated, deadly flames. Users get an overview of the playing area by crawling to vantage points located throughout the 3-D world. The creative, gritty and sometimes disgusting illustrations are beautifully rendered, placing the user in a realistic roach-world.

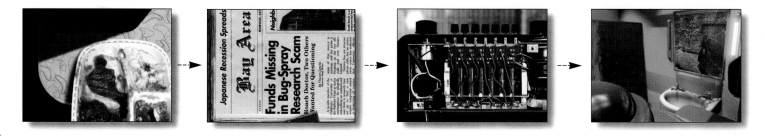

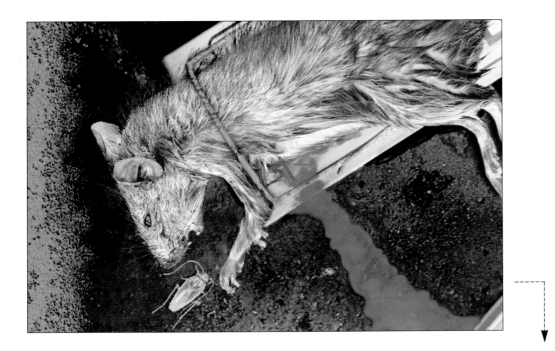

Project *Bad Mojo*
Design Firm Pulse Entertainment Inc.
Art Director Lawrence Chandler
Art Director Special Sequences Charles Rose
3-D Technical Director Dan Meblin
Audio Engineer Bill Preder
Authoring Program Proprietary
Platform Windows

 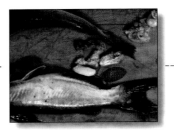

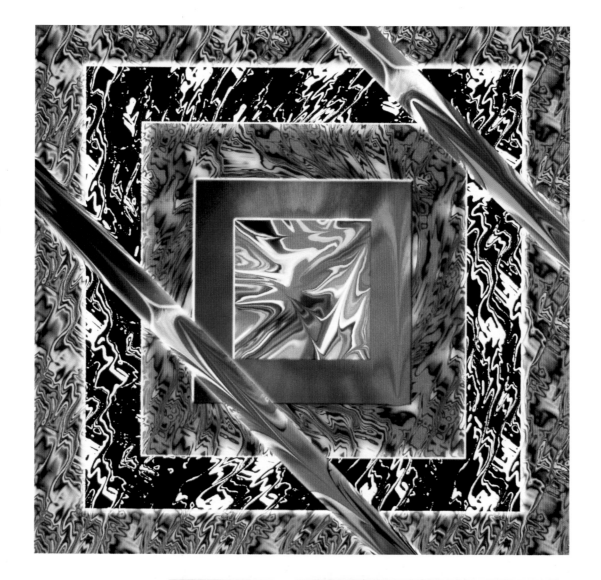

Inner Dimensions
Design Firm McGlothlin
 Associates, Inc.
Designer Gordon McGlothlin
Software Adobe Photoshop,
 Fractal Design Painter, Xaos
 Paint Alchemy, Kai's Power
 Tools
Hardware Macintosh IIX

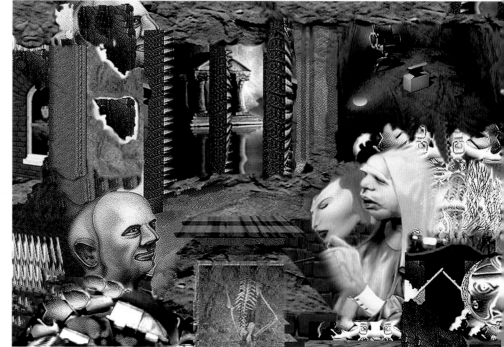

Masked Man's Temple
Designer David Dixon
Software Adobe Photoshop
Hardware Macintosh Quadra 700

To create this image, the designer combined original illustration with digital media techniques in Photoshop.

Dreamscape
Design Firm McGlothlin Associates, Inc.
Designer Gordon McGlothlin
Software Adobe Photoshop, Fractal Design
Painter, Xaos Paint Alchemy, Kai's Power Tools
Hardware Macintosh IIX

Musician Cleto Escobedo's ethnic background was kept in mind when the designers created both Spanish and English interfaces to navigate this interactive publicity presentation. To convey the feeling of music, the designers integrate buttons, text and video into music-orien-ted elements. Saxophone keys on the main menu screen are rollover hotspots that, when clicked, sound a musical note and then take the user to another area of the interactive. Text is set on the right-hand page of a songbook, and a video inter-view is artfully integrated into a glass of wine. One of Cleto's music videos plays in a rendered 3-D window. Both videos can be viewed in either English or Spanish.

Project Cleto Escobedo Interactive Press Kit
Client Virgin Records
Design Firm Tuesday Group Inc.
Designer Richard Parr
Illustrators Steven Mausolf, Nancy Brindley
Programmer Scott Seward
Authoring Program Macromedia Director
Platform Mac/Windows hybrid

With the Beagles
Technique Wet-on-Wet, Virtual Masking,
 Virtual Trace Paper, Painting Words
Illustrator Mario Henri Chakkour

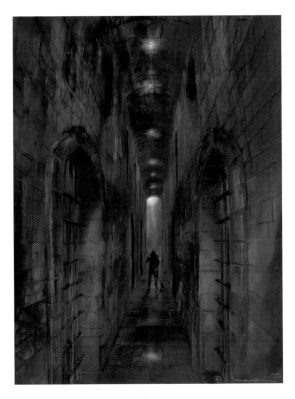

Prison Tunnel
Technique Wet-on-Wet, Virtual
 Masking, Virtual Trace Paper
Illustrator Mario Henri Chakkour

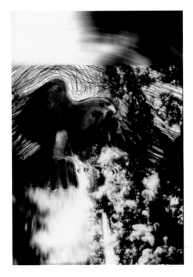

RedHawk
Technique: Wet-on-Wet,
Virtual Masking
Illustrator Karin Schminke

Cactus
Technique Wet-on-Wet, Virtual Trace Paper
Illustrator Kathleen Blavatt

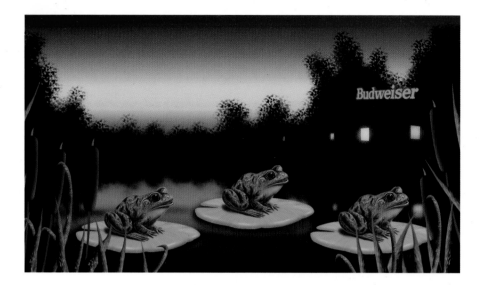

Project Budweiser Frogs
Design Firm Giana Illustration + Design
Illustrator Alan D. Giana
Software Macromedia FreeHand. Fractal Design Painter.
Adobe Photoshop. MetaTools Kai's Power Tools
Client Kelly Design Group/General Cigar Company/
Anheuser Busch

This illustration was created for wrap-around use
on a cigarette lighter. The artist created the basic
shapes for the frog in FreeHand and imported them
into Painter as masks (friskets). This enabled work
on parts of the frog without affecting others. The
background swamp was painted in Photoshop.
The frog and lily pad were then imported into
Photoshop and duplicated.

Project Painting with Computers. Companion CD
Design Firm Techview Interactive Inc.
Illustrator Mario Henri Chakkour
Hardware Macintosh Quadra 950. Wacom ArtZ
Software Fractal Design Painter

This detail of the Companion CD opening segment was completely hand-paint-
ed from scratch in Painter. Lighting effects were later applied at the beginning
and end of the strip.

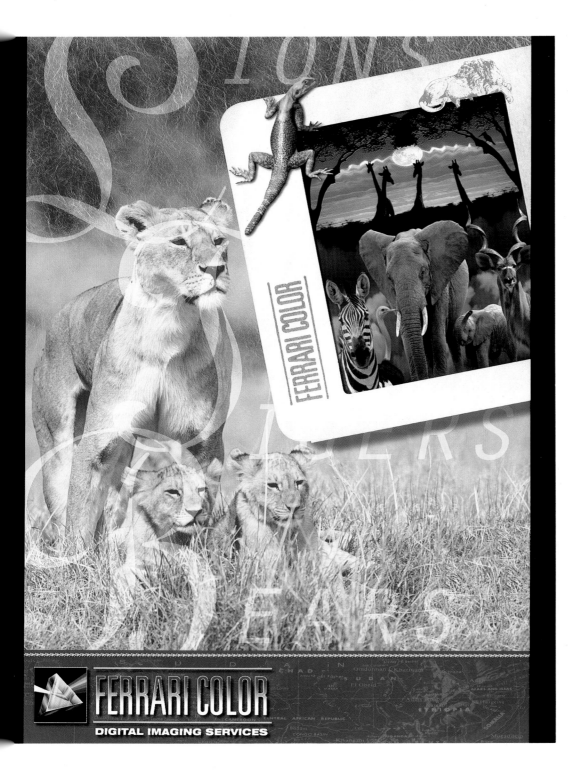

Design Firm Ferrari Color
Designer William Semo
Art Director William Semo
Illustrator William Semo
Photographer Judy Whitcomb
Hardware Macintosh Quadra 950.
 Somet 455. LVT Saturn 1010
Software Adobe Photoshop.
 Adobe Illustrator
Client Ferrari Color

This design demonstrates to clients how 15 separate images can be joined digitally to create a single. seamless picture. Designers included traditional 35mm photographs. manipulated through the computer. to show the design field's link to and evolution from traditional photography.

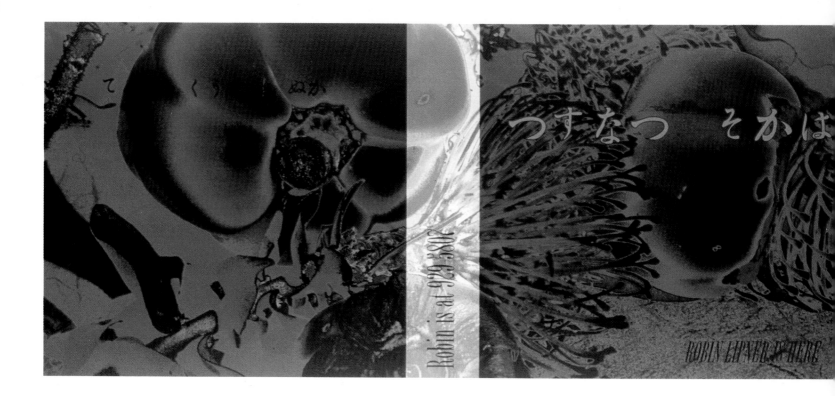

つすなつ　そかは

ROBIN LIPNER IS HERE

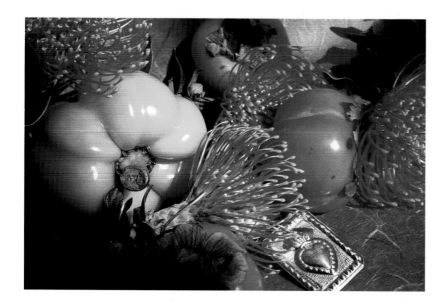

Design Firm Robin Lipner Digital
All Design Robin Lipner
Hardware Macintosh Quadra 840 AV, UMAX scanner
Software Adobe Photoshop

The original photograph was scanned into the computer and manipulated with the "invert" and "solarize" tools. The color distortion was completed globally from image processing in Photoshop.

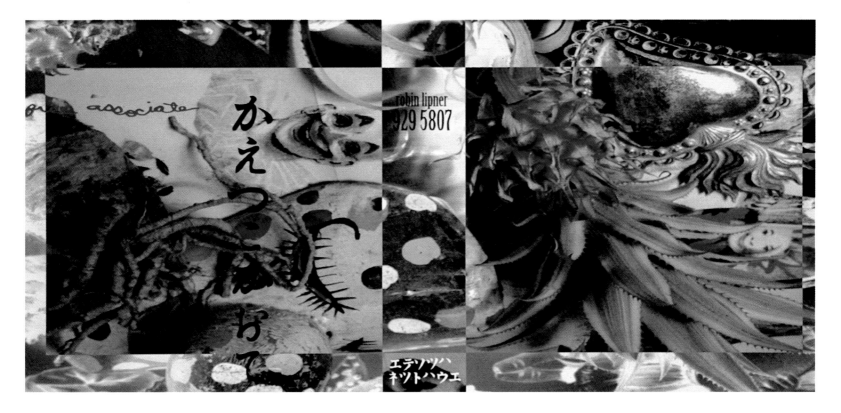

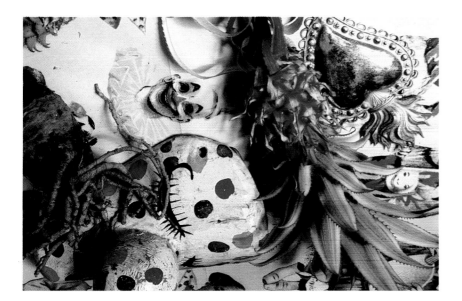

Design Firm Robin Lipner Digital
All Design Robin Lipner
Hardware Macintosh Quadra 840 AV. UMAX scanner
Software Adobe Photoshop

This self-promotion piece. "Free Association," began as a scanned photograph. The image was then distorted by nonproportional scaling, inverted, and accented with Japanese characters.

The Dark Eye—based on the stories of Edgar Allan Poe—consists of a 3-D universe divided into four separate worlds, two of which are shown here. It features the distinctively rough voice of William S. Burroughs, the main character who narrates the game and reads two of Poe's short stories in their entirety.

The Dark Eye's opening screen uses sepia tones; the colors and its artfully illustrated phrenology diagram set the mood for the haunting worlds of *The Dark Eye*. But the first design element that really engages the user's attention is the hand, an element used for navigation throughout the game. The use of a real hand as a cursor, translucent when nothing is activated but solid when it rolls over an active element, adds an eerie feeling to the game. The hand's ability to grasp objects such as door knobs, and to point in the direction of navigation makes for even more eeriness.

The Dark Eye interface enables interaction with other characters to obtain hints and clues that help to solve the mystery of each world.

There are many pitfalls, though: seemingly harmless actions like searching other character's eyes for clues or gazing into a shiny knife cause blackouts, after which players can come to in another world such as the one shown below, based on Poe's The Cask of Amontillado.

Project *The Dark Eye*
Design Firm Inscape
Creative Director Russell Lees
Programmers Erik Loyer, Brock LaPorte
Authoring Program Macromedia Director
Platform Mac/Windows
Voiceover William S. Burroughs
Music Thomas Dolby and Headspace

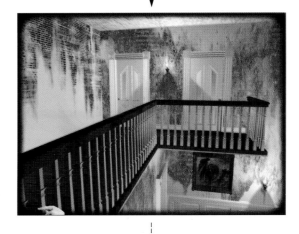

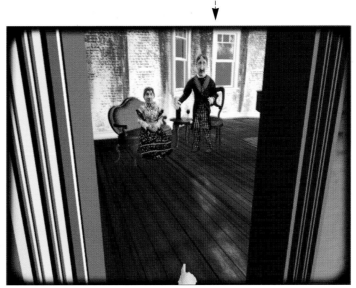

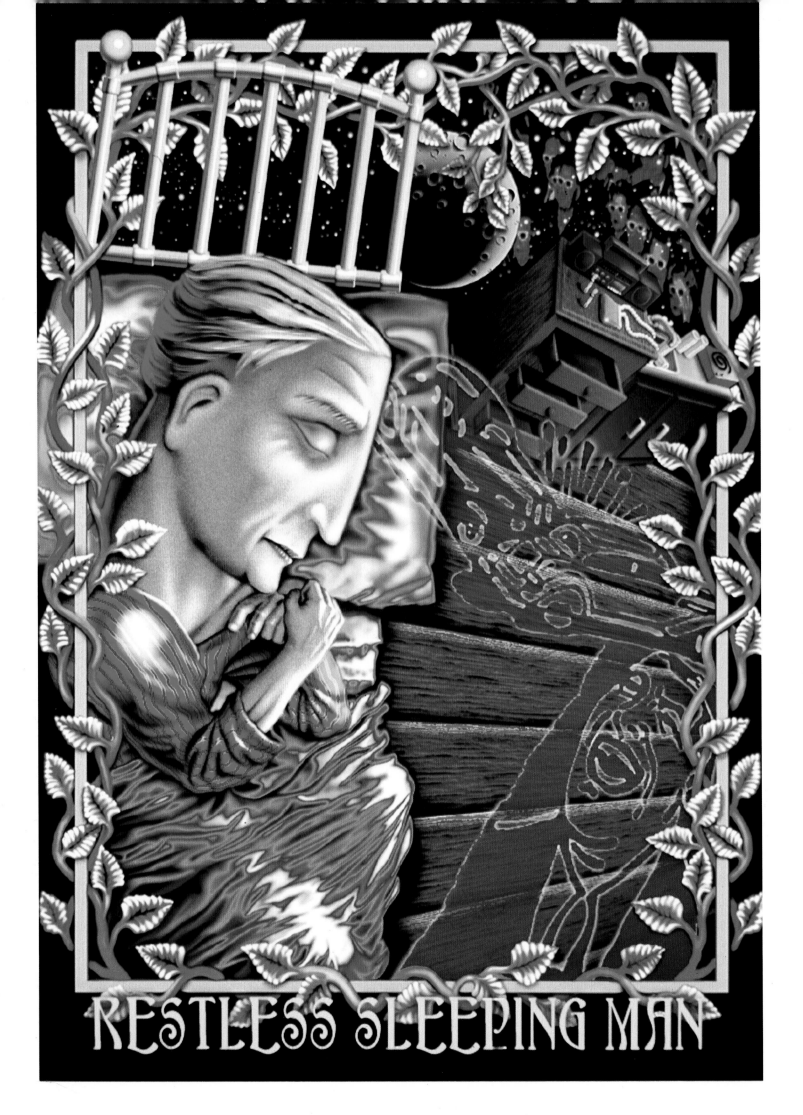

RESTLESS SLEEPING MAN

Using various patterns in Painter, the designer created this card with various colors on the computer.

Valentine's Day Card
Design Firm Imagewright
All Design Annie Higbee
Client Self-promotion
Software Fractal Design Painter
Hardware Macintosh

Restless Sleeping Man
Design Firm Eyebeam
All Design Greg Carter
Client Self-promotion
Software Adobe Illustrator,
 Adobe Photoshop, KPT Bryce
Hardware Macintosh

Scanned-in images were combined with Photoshop painting techniques in various files to produce this design.

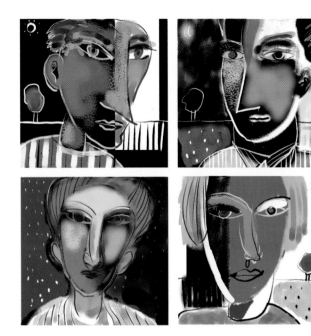

Four Faces
Technique Wet-on-Wet. Virtual Trace Paper
Illustrator Susan LeVan

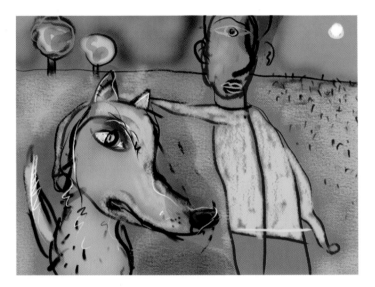

A Boy and His Grey Dog
Technique Wet-on-Wet. Virtual Trace Paper
Illustrator Susan LeVan

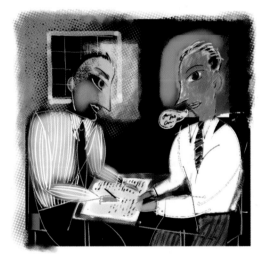

The Agreement
Technique Wet-on-Wet. Virtual Trace Paper
Illustrator Susan LeVan

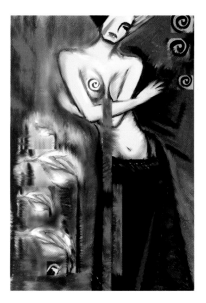

Séance
Technique Wet-on-Wet, Virtual Trace Paper, Virtual Masking, Painting Photographs
Illustrator Steve Campbell

Womanhood
Technique Wet-on-Wet, Virtual Trace Paper
Illustrator Kathleen Blavatt

The Seven
Technique Wet-on-Wet, Virtual Trace Paper, Virtual Masking
Illustrator Steve Campbell

Go Little Pot Go
Technique: Wet-on-Wet, Virtual Trace Paper, Virtual Masking
Illustrator Steve Campbell

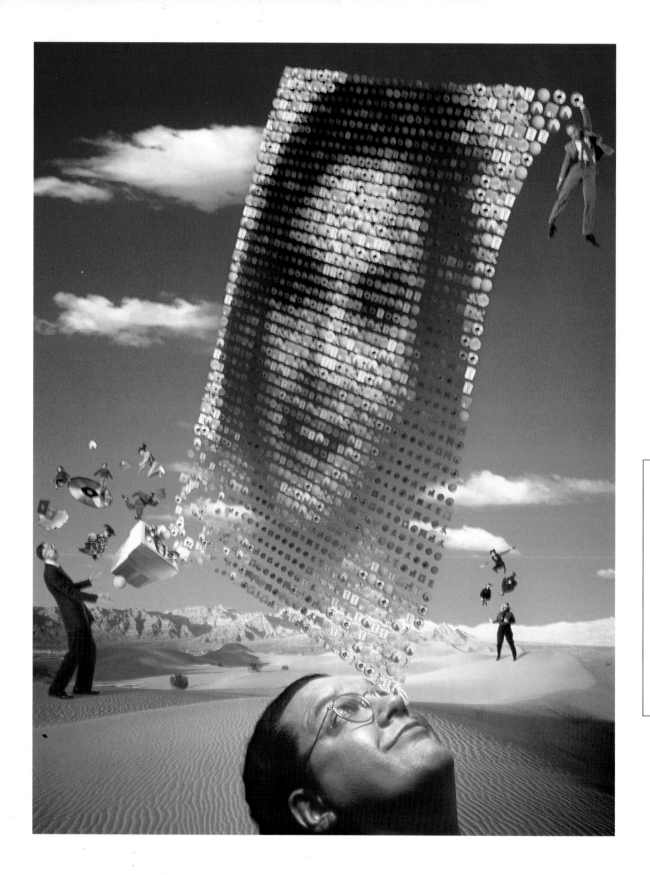

Design Firm R/GA Digital Studios
Art Director Ilona Jones
Digital Design R/GA Print
2-D, 3-D Animation R/GA Print
Photographer Ryszard Horowitz
Hardware Macintosh, Silicon
 Graphics workstation
Software Imrender, Adobe
 Photoshop
Client AT&T Bell Laboratories

This face image was created with scanned images of compact disks and computer equipment. Designers distorted the original photographs, both the facial component and the background, in Photoshop and Imrender.

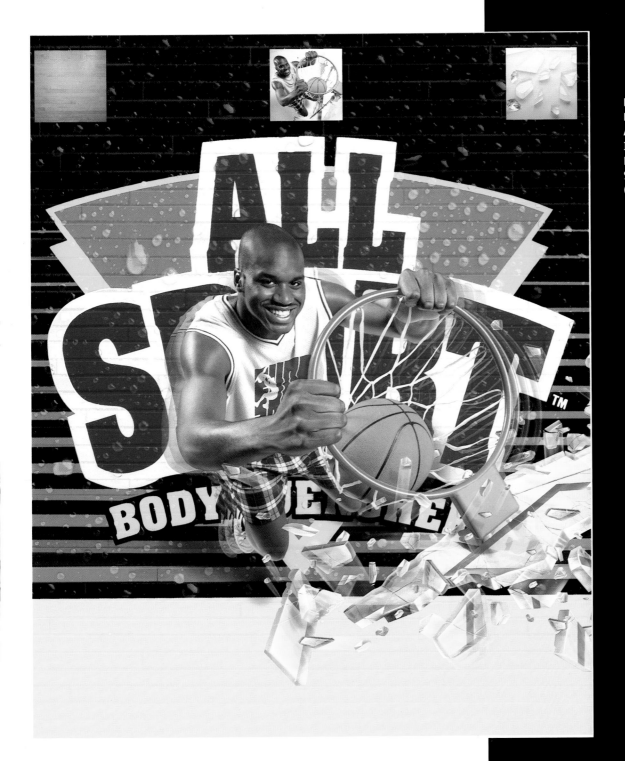

Design Firm Studio 212°
Designer Rob Reed
Art Directors Rob Reed, Tom Collins
Illustrator Studio 212°
Hardware Quantel Graphic Paintbox®
Software Quantel Graphic Paintbox®
Client All Sport/BBD Needham

This image of basketball star Shaquille O'Neal was made from a 35mm transparency and heavily retouched to sharpen the figure. The entire background and all gloss charts were illustrated. including shadows and movement lines.

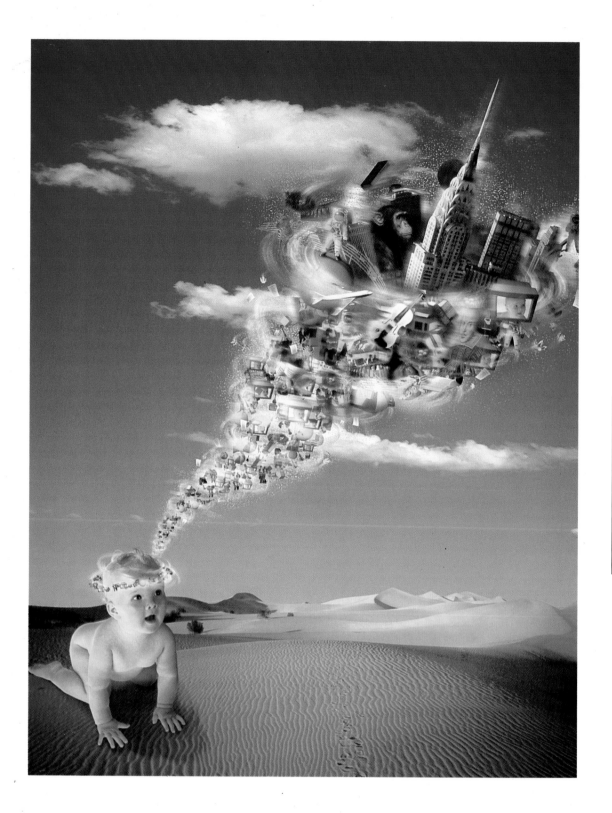

Design Firm R/GA Digital Studios
Art Director Anestos Tritchonis, CME
Digital Design R/GA Print
2-D, 3-D Animation R/GA Print
Photographer Ryszard Horowitz
Hardware Macintosh, Silicon Graphics
 workstation
Software Imrender, Adobe Photoshop
Client 3M

The spiral-blurred effect in these scanned, still photographs was accomplished with Imrender. The shots of the baby and the background were then manipulated with computer-spun elements.

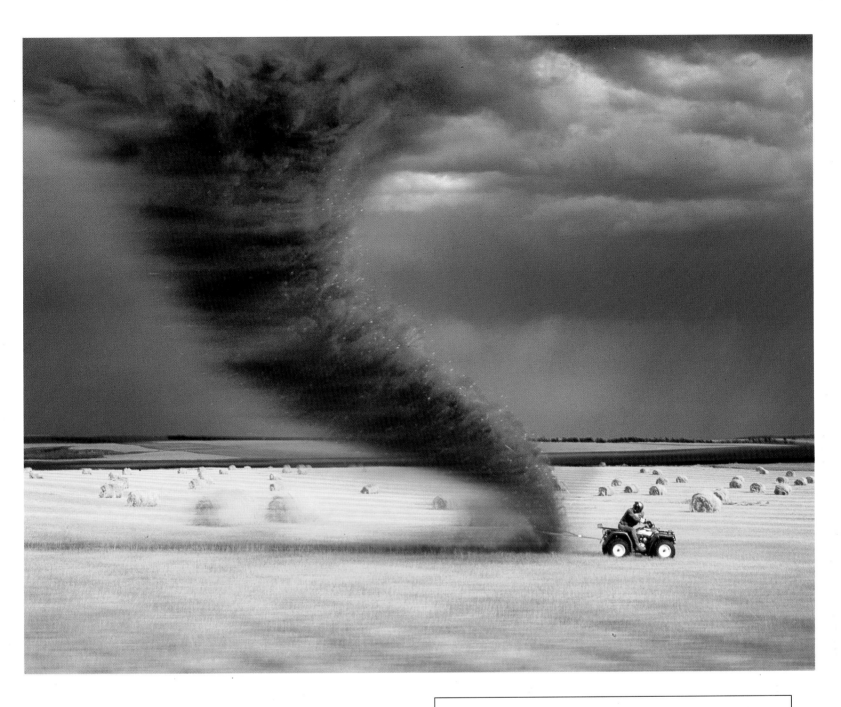

Design Firm Bozell, R/GA Digital Studios
Art Director M. Newhoff
Digital Design R/GA Print
2-D, 3-D Animation R/GA Print
Photographer Eric Meola
Hardware Macintosh, Silicon Graphics workstation
Software Imrender, Adobe Photoshop
Client Kawasaki

For this recent advertisement campaign, designers harnessed a tornado to a tractor by digitally combining photographic elements and backgrounds. Three-dimensional particle-systems' effects were added to create the twister's hay swirl.

Amnesty Interactive is one of the most compelling social activism CD-ROMs. Designed to teach the concept of human rights and to promote Amnesty International's Universal Declaration of Human Rights, *Amnesty Interactive* draws strength from its moral and ethical message, and is supported by scratch art illustrations created by Nancy Nimoy. Using powerful black-and-white imagery, voiceovers, music, illustration, and video, the designers have created a uniquely personal look into the lives of victims of political and social strife.

The tone of the piece is set with the introductory screen, which segues into the contents screen with a startling machine gun sound. The buttons on the contents screen are beautifully rendered icons, each conveying a feeling of movement and urgency emblematic of the content. Background art and borders carry the same look and feel as the contents screen, visually unifying the project.

The five sections carry a powerful statement, each introduced by Leonard Nimoy. The "Rights" section combines voiceover and stop-motion animation; "Ideas" leads to a timeline of important happenings; "Voices" comprises interviews and music by activist singers such as Jackson Browne and Peter Gabriel.

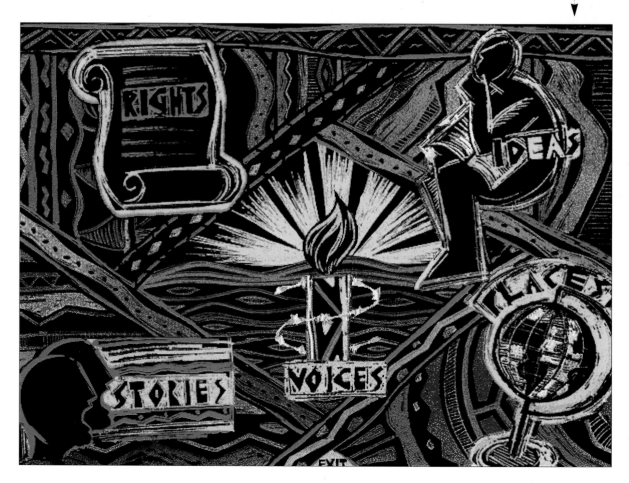

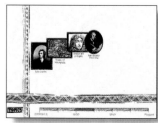

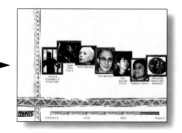

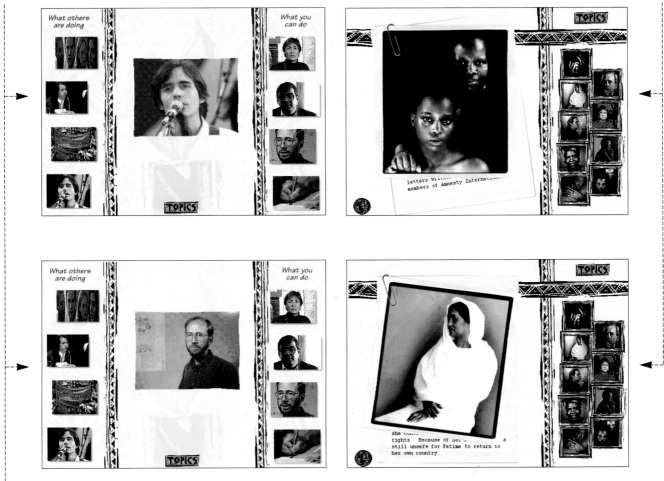

Project *Amnesty Interactive*
Client Amnesty International USA
Design Firm Ignition
Designers Ray Kristof & Eli Cochran
Illustrator Nancy Nimoy
Programmers Eli Cochran. Chris Thorman
Voiceover Leonard Nimoy
Authoring Program Macromedia Director
Platform Mac/Windows PC

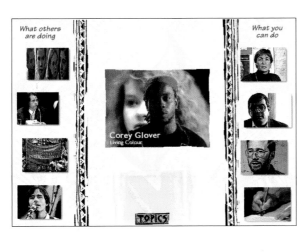

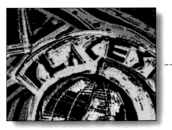

Product Brochure Illustration
Design Firm Axelsson & Co
Art Director Robert Kirtley
Designer Philip Nicholson
Client DIAB
Software Adobe Illustrator,
 Adobe Dimensions, Adobe
 Photoshop, Strata StudioPro
Hardware Macintosh Quadra 950

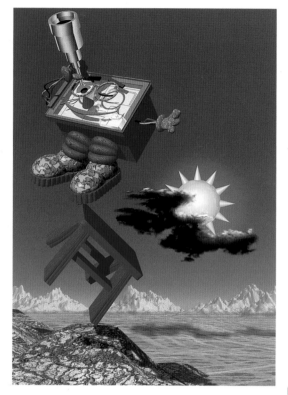

The foil was modeled in StudioPro with use of a diamond pattern bump map. The graphics were taken from Illustrator and Dimensions, and the bottle and ribbon were drawn and painted in Illustrator and Photoshop.

This high-tech cartoon character was created in StudioPro so it would be possible to use the illustration in various promotions.

Brochure Illustrations
Design Firm Pyramid Communications
Art Director Rune Osberg
Designer Philip Nicholson
Client Tour & Anderson
Software Adobe Illustrator,
 Strata StudioPro, KPT Bryce
Hardware Power Macintosh 8100/110

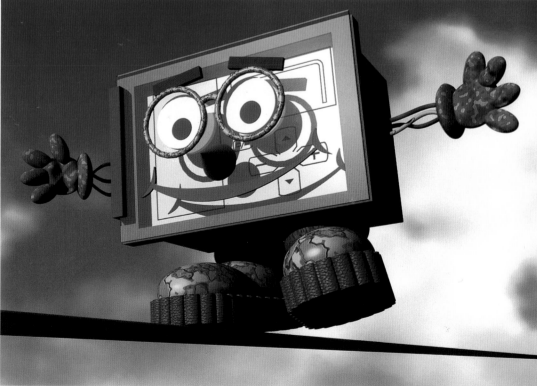

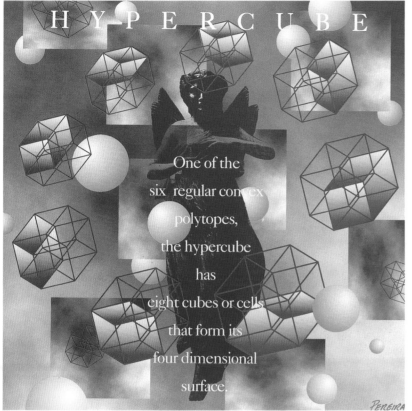

One of the
six regular convex
polytopes,
the hypercube
has
eight cubes or cells
that form its
four dimensional
surface.

PEREIRA

Hypercube

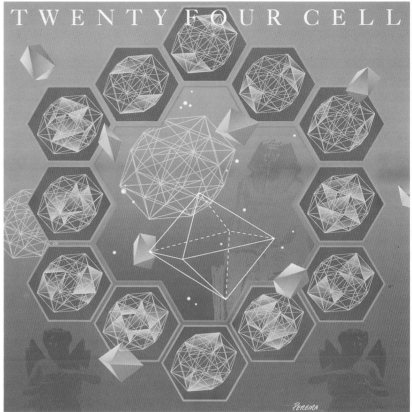

PEREIRA

Twenty Four Cell

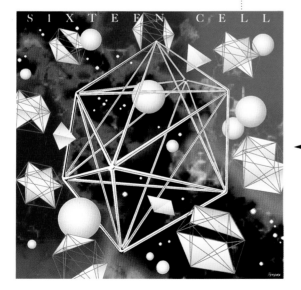

S I X T E E N C E L L

PEREIRA

Sixteen Cell

Design Firm Eduino J. Pereira Graphic Design
Designer Eduino J. Pereira
Client Self-promotion
Software CorelDraw
Hardware 386 PC

These pieces were created entirely in CorelDraw with the exception of the imported angel image. The angel was scanned from a nineteenth century engraving (public domain). The background skyscape was created using CorelDraw postscript background fills.
The eight floating geometric renderings depict a series of "hypercubes." These are representations of a four-dimensional geometric shape, known as a "polytope," containing eight cubes on its surface. Each of the eight renderings highlights a cube which forms part of the surface of the hypercube.

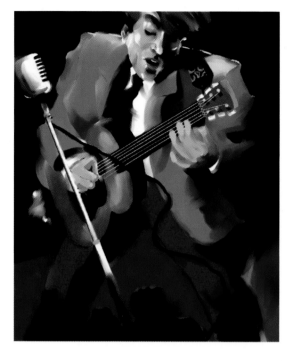

Guitar Player
Technique Wet-on-Wet, Virtual Masking, Virtual Trace Paper
Illustrator Kerry Gavin

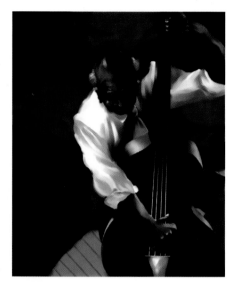

Solo Bassist
Technique Wet-on-Wet, Virtual Masking, Virtual Trace Paper
Illustrator Kerry Gavin

Territory
Technique Wet-on-Wet, Virtual Trace Paper
Illustrator Debi Lee Mandel

Clouds
Technique Wet-on-Wet, Digital Airbrush
Illustrator Dewey Reid

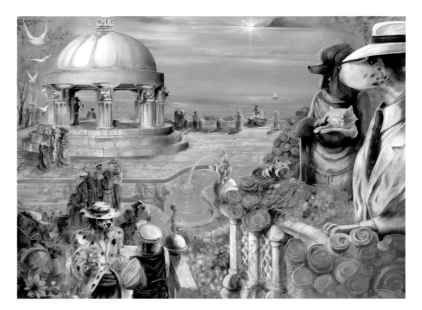

The Great Gatsbone
Technique Wet-on-Wet, Virtual Masking, Virtual Trace Paper, Digital Airbrush
Illustrator Mario Henri Chakkour

Rasterops
Technique Digital Airbrush, Painting Photographs, Painting Words, Wet-on-Wet,
 Painting 3D Images, Digital Collage
Illustrator Dewey Reid for Colossal Pictures

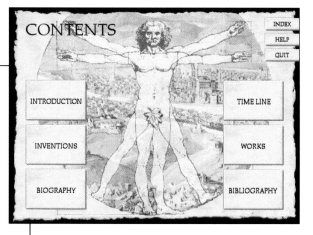

Leonardo the Inventor encourages interactive exploration of the inventions and life of one of the world's great thinkers and artists. The interface for navigating the CD-ROM features easily identifiable buttons that link the user to six main areas, characterized by thoughtful detail like easy-to-read, anti-aliased type on the biography text. Users access information easily, with no more than three layers separating them from desired content. The use of parchment as a background on each screen evokes a sense of studying Leonardo's original time-worn sketches and illustrations.

Perhaps the most creative detail of the project is the ingenious animation of Leonardo's sketches of flying inventions—though they never flew in life, they do fly here.

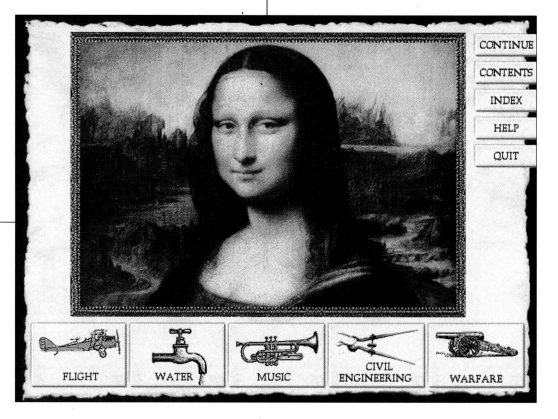

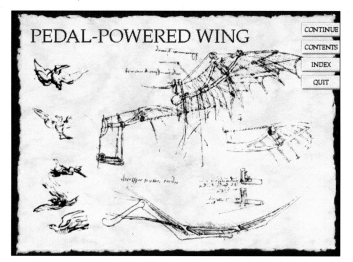

Project Leonardo the Inventor
Design Firm SoftKey International
Platform Mac/Windows

America's Funniest Home Videos' CD-ROM game, titled *Lights! Camera! InterAction!* has something to offer couch potatoes, would-be film editors and game players.

Lights! Camera! Interaction! takes place in a suburban American house with three playing levels. Those who tear themselves away from the couch potato level will find the editing level on the second floor, and the game room in the attic.

The three levels in the house are three-dimensional rooms where all of the interaction takes place. Each level of the house requires varying degrees of user involvement. The first floor lets users sit back and run through dozens of home videos, the second floor has an editing suite where users splice together their own home videos from stock footage, and the attic lets users play a game.

Project *America's Funniest Home Videos*
Lights! Camera! InterAction!
Design Firm Graphix Zone Inc.
Designer Susan Dodds
Programmers Bill Pierce, Sean Dunn
Authoring Program Apple Media Tool Kit
Platform Mac/Windows
Production Date October 1995

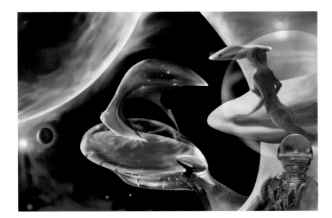

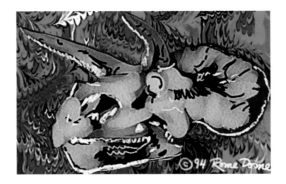

Genesis One
Technique Wet-on-Wet, Virtual Masking, Virtual Trace
 Paper, Digital Airbrush
Illustrator Mario Henri Chakkour

Triceratops Skull
Technique Wet-on-Wet, Virtual Masking, Virtual Trace Paper
Illustrator Romeo A. Esparrago, Jr.

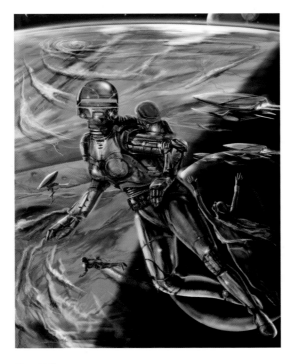

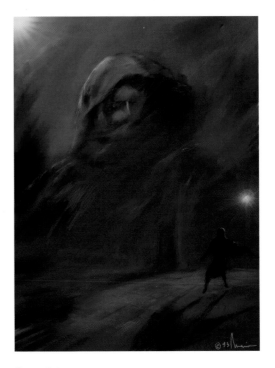

Free-Fall
Technique Wet-on-Wet, Virtual Masking,
 Virtual Trace Paper, Digital Airbrush
Illustrator Mario Henri Chakkour

Street Lamp
Technique Wet-on-Wet, Virtual Masking, Virtual
 Trace Paper
Illustrator Mario Henri Chakkour

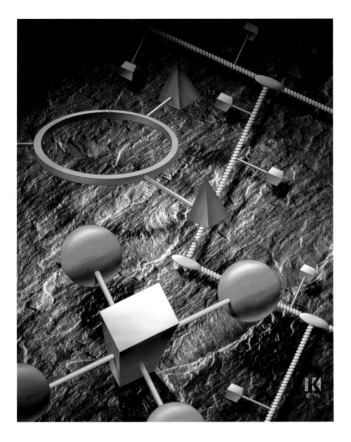

Networking
Technique Wet-on-Wet, Virtual Masking, Virtual Trace
Paper, Painting Photographs
Illustrator Stephen Kramer

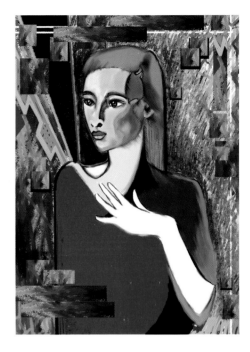

Wendy
Technique Wet-on-Wet,
Virtual Trace Paper
Illustrator Kathleen Blavatt

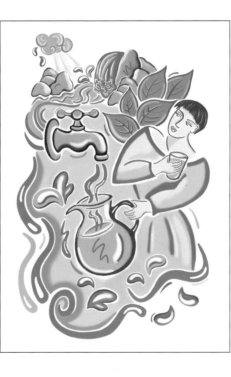

Water Resources
Technique Wet-on-Wet, Virtual
Trace Paper
Illustrator Ayse Ulay

Jazz
Design Firm Robin Lipner Digital
All Design Robin Lipner
Client Self-promotion
Software Alias Power Animator
Hardware Silicon Graphics

All of the elements of this promotional illustration were created with three-dimensional effects except for the photograph outside of the window.

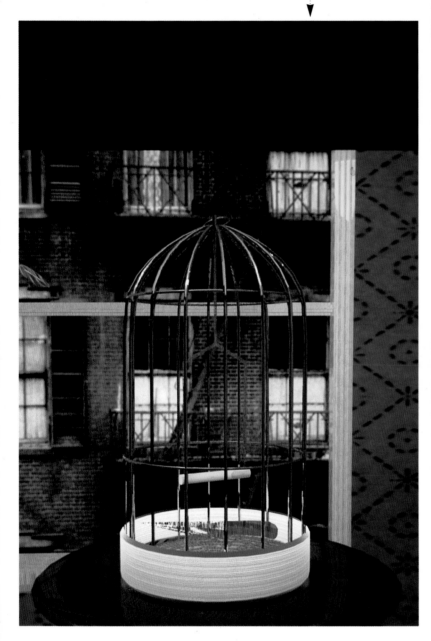

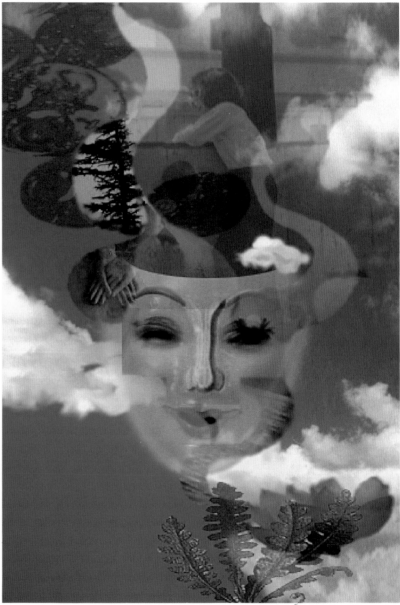

Scent
Design Firm Robin Lipner Digital
All Design Robin Lipner
Client Self-promotion
Software Adobe Photoshop
Hardware Macintosh Quadra
840 AV. UMAX Scanner

The Mardi Gras mask in this image was taken from a video frame that captures the face.

Free Associate
Design Firm Robin Lipner Digital
All Design Robin Lipner
Client Self-promotion
Software Adobe Photoshop. Adobe Illustrator
Hardware Macintosh Quadra 840 AV. UMAX Scanner

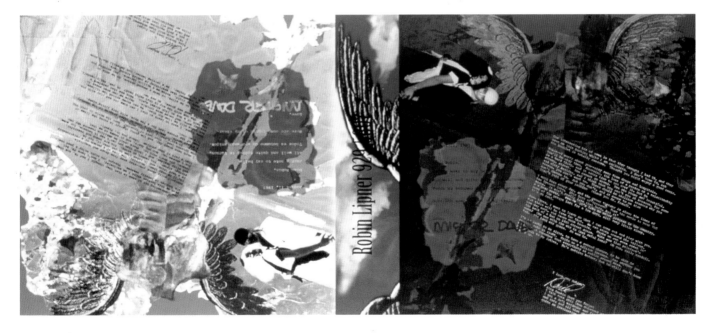

Bye Dave
Design Firm Robin Lipner Digital
All Design Robin Lipner
Client Self-promotion
Software Adobe Photoshop. Adobe Illustrator
Hardware Macintosh Quadra 840 AV. UMAX Scanner

Cloralex Still 1
Technique Animation Cels
Illustrator Ron Price

Cloralex Still 2
Technique Animation Cels
Illustrator Ron Price

Cloralex Still 3
Technique Animation Cels
Illustrator Ron Price

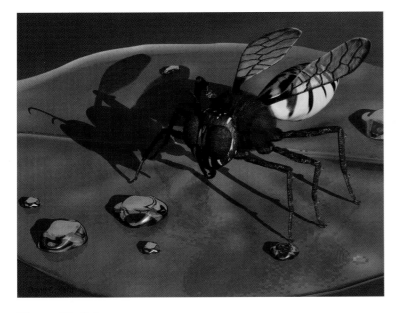

Wasp on Lily Pad
Technique Painting 3-D Images
Illustrator David C. Kern

Hottub
Technique Painting 3-D Images
Illustrator Derrick Carlin

Multimedia
Technique Painting 3-D Images. Digital Collage. Digital Airbrush
Illustrator Henk Dawson

Design Firm Dewitt-Anthony, R/GA Print
Art Director Dann Dewitt
Photographer Dan Wilby
Digital Design R/GA Print
2-D, 3-D Animation R/GA Print
Hardware Macintosh. Silicon Graphics workstation
Software Adobe Photoshop. Imrender

This image was created by combining traditional photography techniques with two-dimensional compositing software.

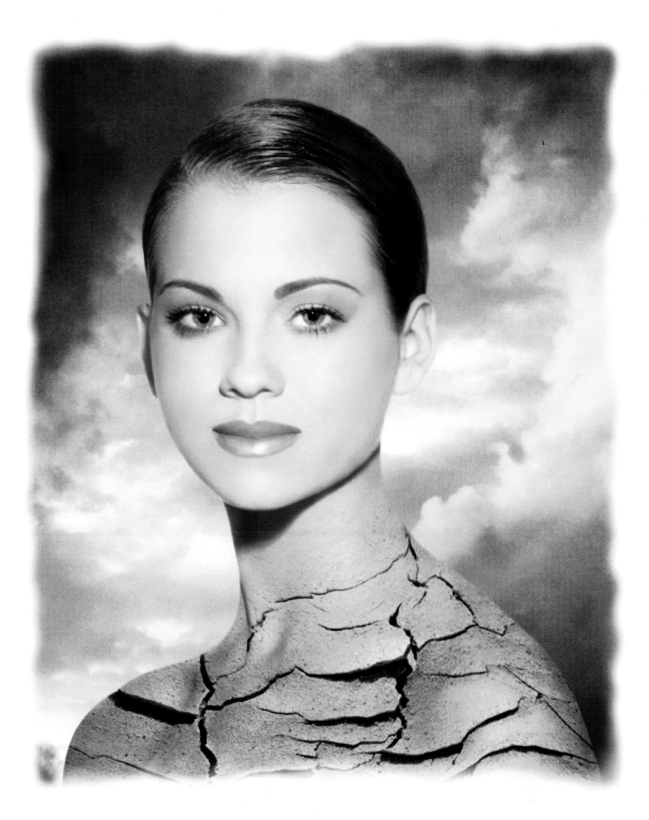

For this scene, a model was photographed against a white background, and the photo was then composed onto a background image of the sky. Designers then texture-mapped an image of cracked, desert sand onto her torso.

Art Director Floyd M. Dean
Illustrator Hersh Gutwillig
Photographer Floyd M. Dean
Hardware Leafscan 45,
 Macintosh and UNIX based
 work station
Client Dean Digital Imaging

Architects of a New Medium is an award-winning CD-ROM that lets users explore a multimedia world created by Micro Interactive. Using an architectural site plan as its main contents screen, the designers created an exceptionally integrated interface.

By exploring virtual 3-D rooms within allegorical buildings, the user gains firsthand information regarding the company's design processes for major clients. Impressive multimedia elements, such as the placement of a video presentation on a laptop computer screen, an animated character on a 35mm film strip, or the use of a blueprint for navigating rooms demonstrate Micro Interactive's creative and technological capabilities.

The most important element of the interface is the use of well-written narration, which conveys most of the information to the user. Explorers of the virtual environment are greeted by an audio guide who explains each room's purpose.

By clicking on elements in each room, the user learns more about the approach Micro Interactive takes toward fulfilling the client's needs.

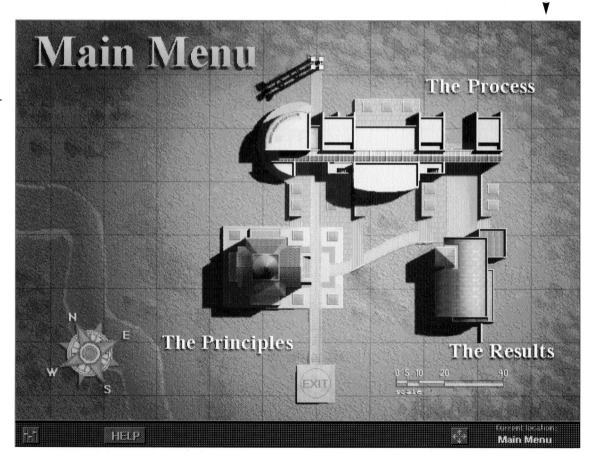

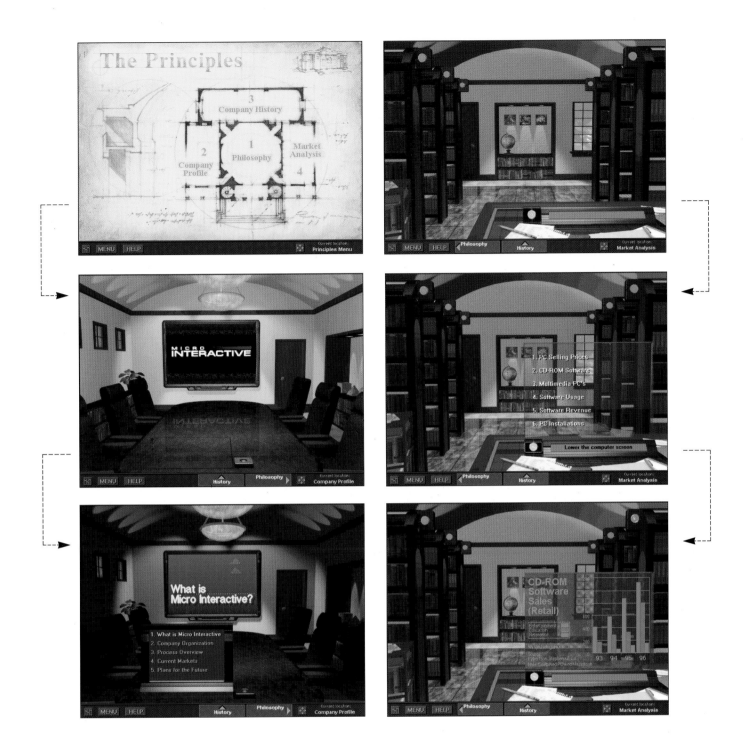

Project *Architects of a New Medium*
Design Firm Micro Interactive Inc.
Creative Director Eric Freedman
Designers Staff
Illustrators Staff
Programmers Derrick Shriver. Staff
Authoring Program Proprietary
Platform Windows

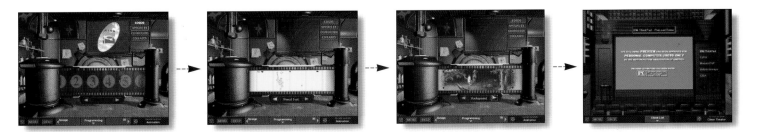

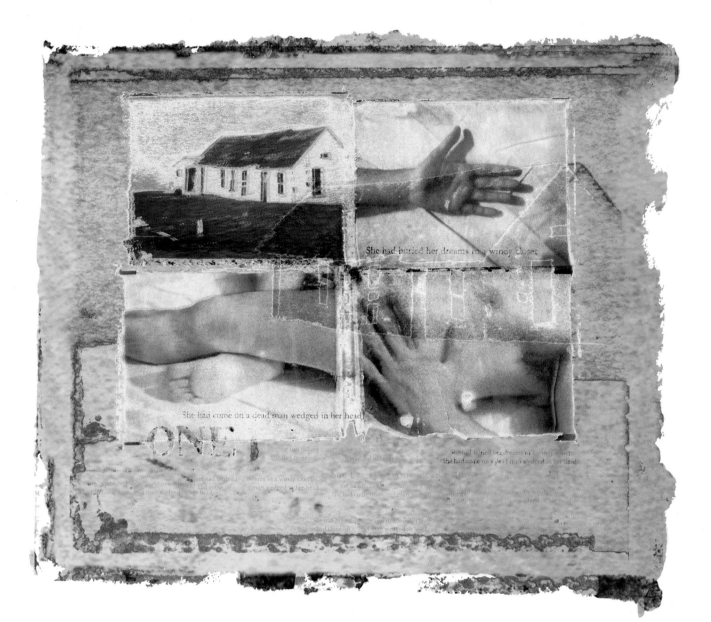

Fine Art Series
Designer Diane Fenster
Software Adobe Photoshop
Hardware Macintosh Quadra 840 AV

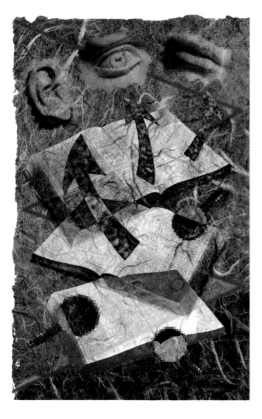

Magazine Cover
Designer Diane Fenster
Client Apple
Software Adobe Photoshop
Hardware Macintosh Quadra 840 AV

The background was taken
from a scan of rice paper.
The zig-zag line was drawn
with the "path" tool and then
stroked using "dissolve"
mode. The interesting color
interplays were a result of
placing objects on layers
assigned to the "difference"
mode.

Advertisement Illustration
Designer Diane Fenster
Ad Agency Goldberg Moser O'Neill
Art Director Mike Moser
Client Dell Computers
Software Adobe Photoshop, Adobe Dimensions,
 Kai's Power Tools
Hardware Macintosh Quadra 840 AV

Spheres in the image were created by
placing a letter on a pattern background
in Photoshop, using "marquee" to select a
circular area, and then applying KPT filter
"glass lens soft." Type was created in
Dimensions, and the texture was applied
using both Photoshop and Kai's Texture
Explorer.

Mike
Technique Wet-on-Wet, Virtual Trace Paper, Digital Collage
Illustrator Jan Ruby-Baird

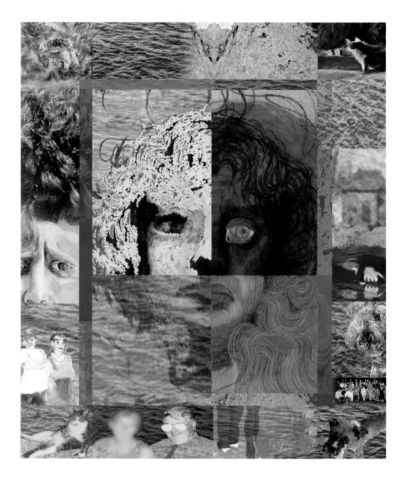

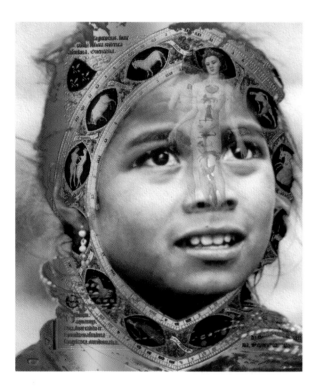

The Books of Hours
Technique Painting Photographs, Digital Collage, Virtual Masking
Illustrator Dorothy Simpson Krause

Caroline
Technique Wet-on-Wet, Virtual Trace Paper, Digital Collage
Illustrator Jan Ruby-Baird

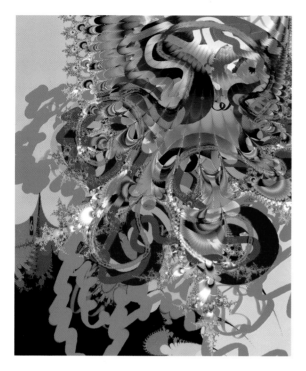

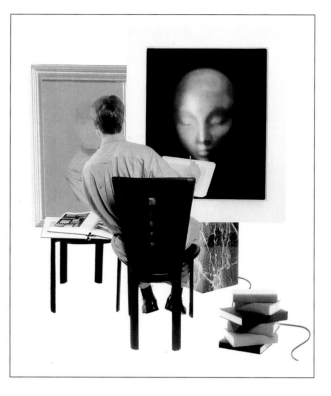

Fthr Hg
Technique Wet-on-Wet. Digital Collage. Virtual Masking.
 Digital Airbrush
Illustrator Corinne Whitaker

A bridge of Technologies & Ideas
"Technology reflects the human mind,
without ideas machines we become"
Technique Painting Photograph. Digital Collage
Illustrator Andy Gordon

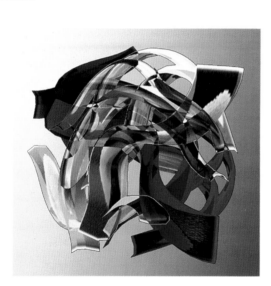

breakinG ouT
Technique Wet-on-Wet. Digital Collage. Virtual Masking.
 Digital Airbrush
Illustrator Corinne Whitaker

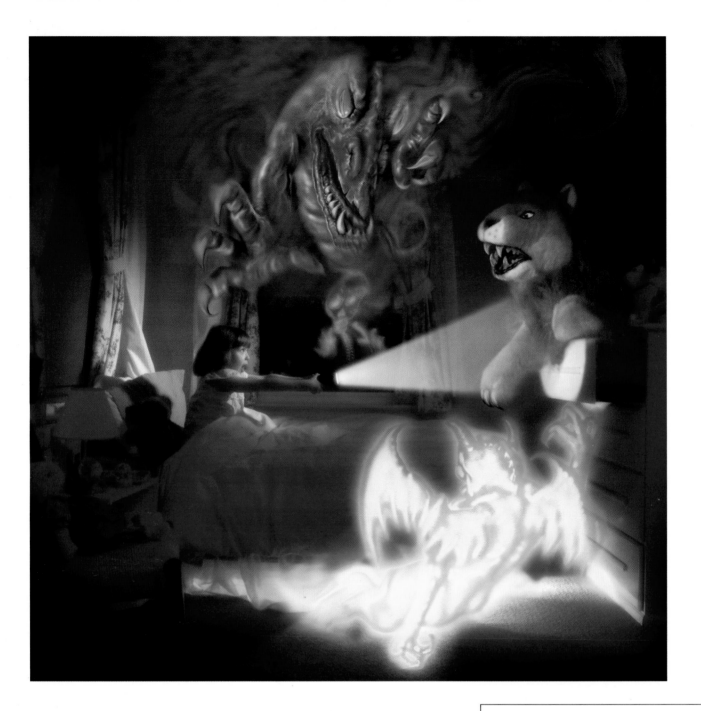

Design Firm Philip Howe Studio
Designer Philip Howe
Art Director Dianne Bartley
Photographer Ed Lowe
Hardware Macintosh Quadra 950, Power Macintosh 200M RAM
Software Adobe Photoshop, Fractal Design Painter
Client Kiwanis International

The designer scanned in the original photograph of the girl in bed. The monster and animal elements were created and painted over the photograph in Photoshop.

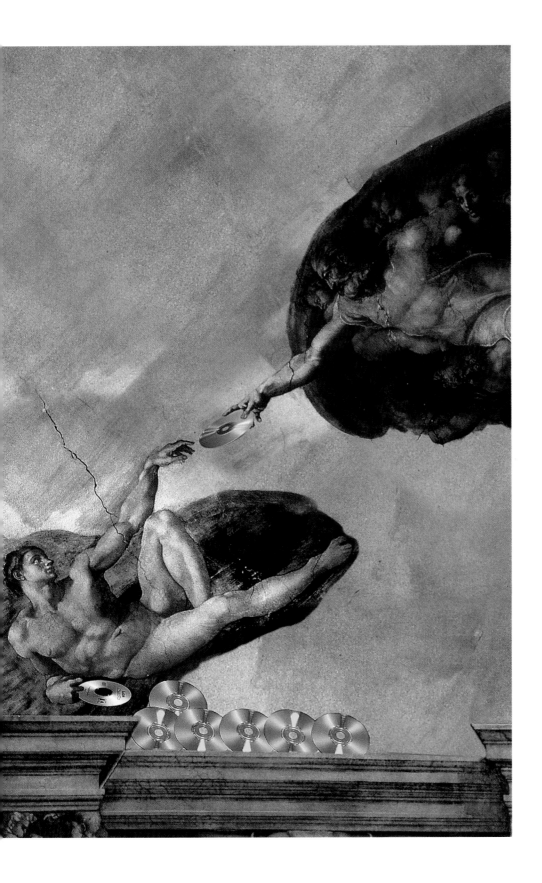

All Design Stanley Rowin
Hardware Macintosh Quadra 950
Software Adobe Photoshop
Client Boston Computer Society

This magazine cover of the compact disc issue was created with a Photo CD scan of compact discs.
In Photoshop. this scan was added into the image of the Sistine Chapel. The major challenges were scanning in the images. and then making the horizontal image fit the vertical proportions of the cover.

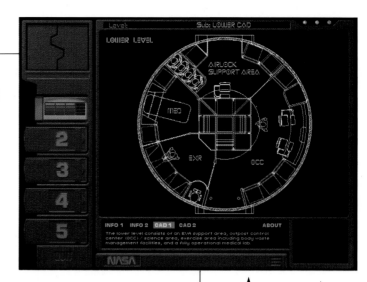

Marsbook CD, produced by Human Code in 1993 for NASA, is a virtual guide to NASA's Initial Planned Mars Habitat. It was created using an early version of what was then MacroMind Director and used the first release of QuickTime as such, it represents an immense effort of 3-D rendering and data organization. Remarkably, this presentation is satisfying even though there is no audio track. The intricate detail of the rendering, the ability to zoom in, and the precise engineering notes are accessed quickly, quietly and efficiently, seemingly in the silence of space.

Five "LevelKeys" allow viewers to examine both the interior and exterior of each level in the station in several ways: as wireframe floor plans, as fully rendered diagrams showing construction dimensions and mechanical cutaways, or as interactive video walk-throughs. The viewer controls the direction and speed of walkthroughs using the small Navigation Window in the upper left corner. Clicking on an object in the Navigation Window interrupts the tour and displays a detailed 24-bit color image of the object in the large display window, and descriptive text in the information window below. When viewing exterior images of the habitat, the Navigation Window displays a thumbnail image that rotates in any direction by clicking and dragging. The rotated image is then displayed in large format on the main viewscreen.

Additionally, a lunar module is accessible for viewing via the NASA control panel. Though not as obsessively detailed as the Mars Habitat presentation, several walkthrough presentations are available.

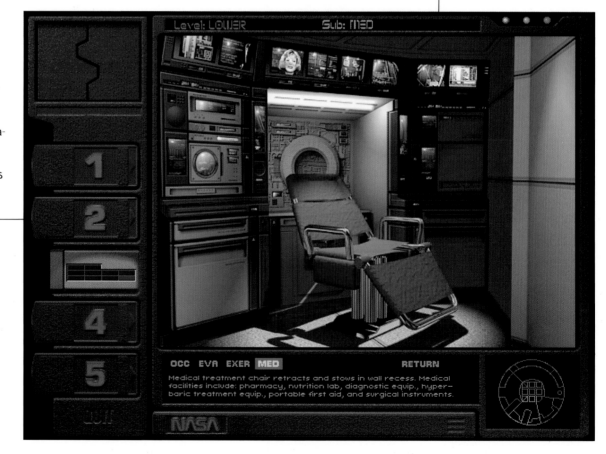

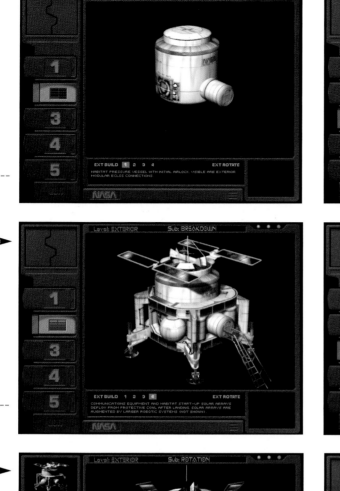

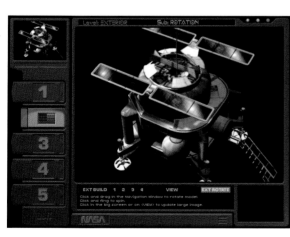

Project *Marsbook CD*
Client NASA
Design Firm Human Code. Inc. and Design Edge Media Integration
Designers Chipp Walters, Lindsay Gupton,
 Reed McCullough. Nathan Moore. David Gutierrez
Programmer Gary Gattis
Authoring Programs SuperCard. Macromind Director
Platform Mac

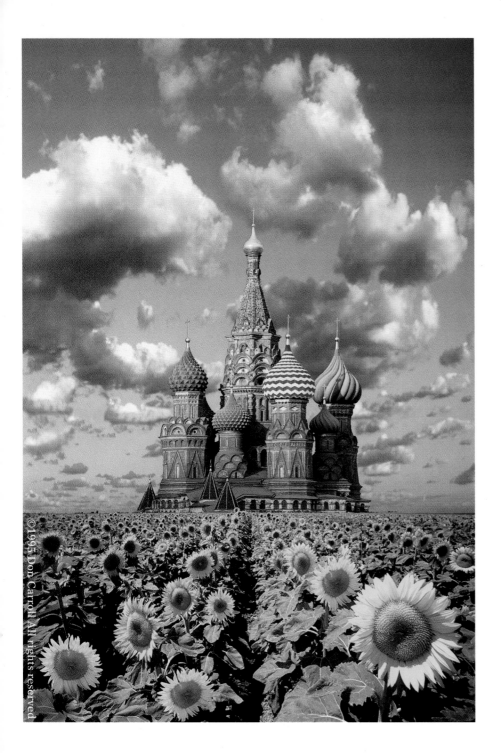

Design Firm Multi Dimensional Images
Computer Designer Noriko Iizuka
Art Director Don Carroll, Fred J. Sklenar
Photographer Don Carroll
Hardware Macintosh Quadra 950 139M
Software Adobe Photoshop

The designer took separate photographs of a sunflower field and St. Basil's church in Moscow to create this image. Both photographs were scanned, and the St. Basil's image was digitally refined on the computer by defining its color, removing the gray sky, and adding a new sky.

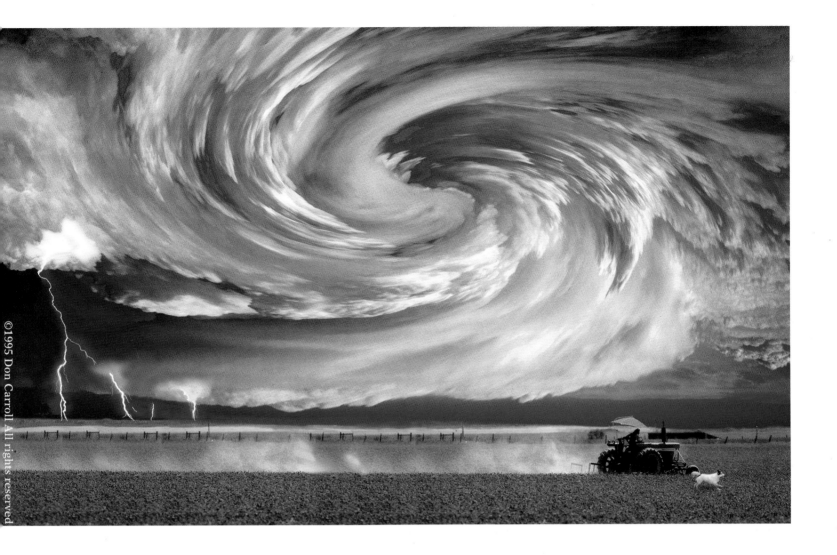

Design Firm Multi Dimensional Images
Computer Designer Noriko Iizuka
Art Director Don Carroll, Fred J. Sklenar
Photographer Don Carroll
Hardware Macintosh Quadra 950 139M
Software Adobe Photoshop

This image was created from four separate elements—the man on the tractor, the dog, clouds, and lightning. On the computer, the designer cloned the image of the field and the dust behind the tractor, and pasted it onto the original photograph, adding openness to the image. He then used the Photoshop "twirl" filter on an aerial cloud shot, and pasted the clouds into the tractor frame, smoothing out the edges. Lighting from a third image was then added, along with the manipulated photograph of the dog. Without the computer, this design would have been impossible.

The *Martial Arts Explorer* offers four different paths of discovery. Each path is represented by an icon that, when clicked, takes users to a different world. Each world has a distinctive look, characterized by Far Eastern art, such as pagodas on the "Explorer's island," an acupuncture model in the "library," or the "journal" used for viewing martial arts techniques.

Two additional contents screen elements include a help button, which activates a small video when clicked, and a preferences box, sliding back to reveal a simulacrum of the interface.

Of all the areas featured on the CD-ROM, the most useful and entertaining is the library. Clicking on a specific area of interest lets the user view instructional videos of martial arts techniques. A Far Eastern influence felt throughout the CD-ROM adds to the atmosphere of the interface, making users feel as if they have actually visited the worlds of *The Martial Arts Explorer*.

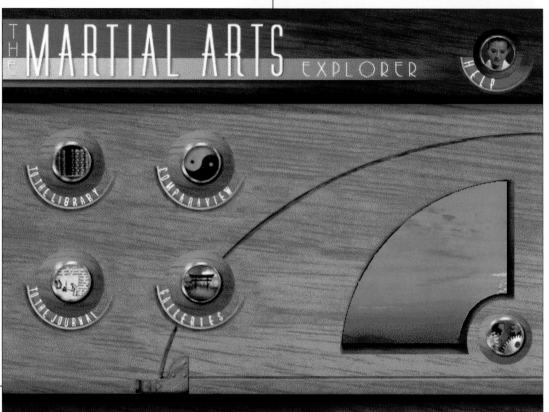

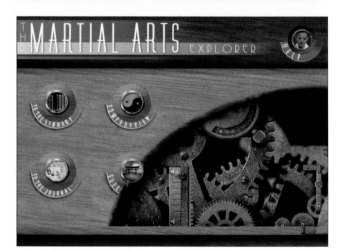

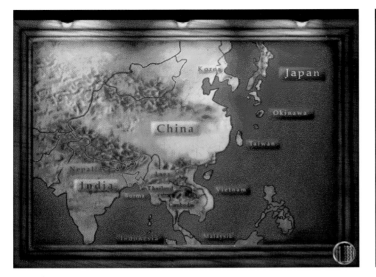

Project *The Martial Arts Explorer*
Design Firm SoftKey International
Designers Staff
Platform Mac/Windows

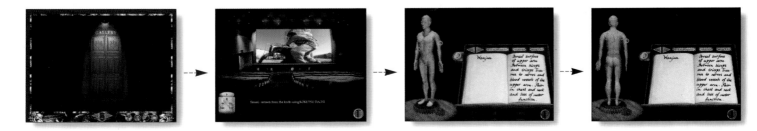

Found Garden-Revelation 3
Technique Digital Collage, Wet-on-Wet
Illustrator Karin Schminke

Found Garden-Revelation 4
Technique Digital Collage, Wet-on-Wet
Illustrator Karin Schminke

Joyride 2
Technique Wet-on-Wet, Painting Photographs, Digital Collage
Illustrator Steven P. Goodman

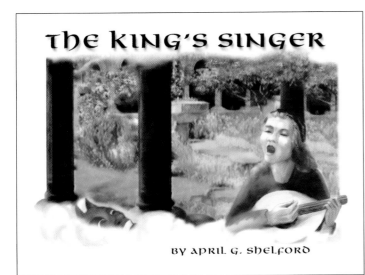

The King's Singer
Technique Digital Airbrush. Painting Photographs. Painting Words. Wet-on-Wet with Virtual Masking
Illustrator Caroline Meyers for O·Town Media

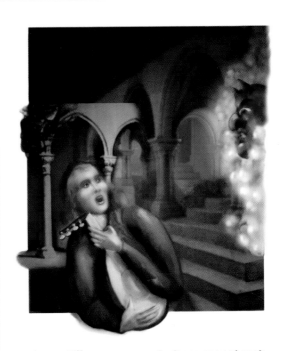

THERE HE WAS, STRANDED IN AN ISLAND OF MOONLIGHT, LAUNCHING A NOTE, A PHRASE, AN ARC OF SOUND, ALL EQUALLY BEAUTIFUL, ALL TERMINATED EQUALLY ABRUPTLY. HIS SECRET TERROR WAS EVIDENT IN THE TENSED MUSCLES OF HIS BACK, HIS GRIP ON THE LUTE'S NECK.

The Singer Loses His Voice
Technique Digital Airbrush. Painting Photographs. Painting Words. Wet-on-Wet with Virtual Masking
Illustrator Caroline Meyers for O·Town Media

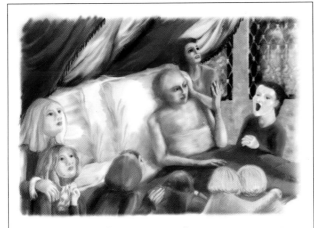

SING FOR ME, THE SINGER SAID, SING FOR ME NOW. ALTHOUGH THE SON DID NOT DESIRE TO SING, HIS FATHER'S VOICE WAS SO IMPERIOUS -- NOT FROM RULE, BUT FROM SUFFERINGS THE SON HAD ONLY HEARD RUMORED -- THAT HE, HEART ACHING, BEGAN TO SING.

The Singer Dies
Technique Digital Airbrush. Painting Photographs. Painting Words. Wet-on-Wet with Virtual Masking
Illustrator Caroline Meyers for O·Town Media

©J.W.Burkey

Design Firm D-Magazine
Designer Cynthia Eddy
Illustrator J. W. Burkey
Photographer J. W. Burkey
Hardware Macintosh II
Software Adobe Photoshop

The original photograph was shot specifically for this magazine article illustration. The image was reduced to black-and-white. the designer changed the color table. created the wavy effects with distortion filters. and stretched the image of the cup in Photoshop.

Design Firm Jamie Cook, Inc.
All Design Jamie Cook
Hardware Pentium/90 256M RAM
Software Altamira Composer,
 Fractal Design Painter

For this project, the surface of the planets was created using Fractal Design Painter. This textured image was color-mapped to spheres that were made in Altamira Composer. All the other objects were masked using Altamira's "spline" tool, and assembled for the final image.

PPM8 (LifeLines) is elegant in its simplicity. The interface is simple, with a row of navigable buttons running along the bottom of the screen, scrolling text, and photos. This design stands apart from others in its subtle use of colors and the use of a hummingbird (with flapping wings) as a cursor.

Moving the hummingbird from left to right switches the direction of the bird, and clicking on a button sends you to another screen accompanied by a trilling bird song.

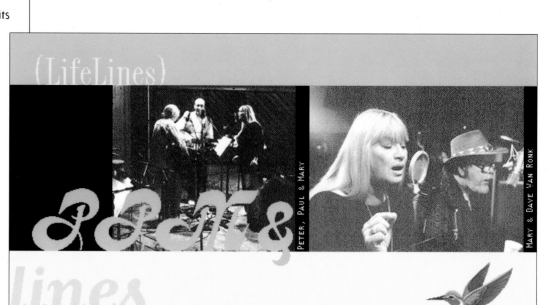

Project *PPM8 (LifeLines)*
Client Warner Bros. Records
Design Firm Post Tool Design
Designers David Karam, Gigi Biederman
Illustration David Karam, Gigi Biederman
Authoring Program Macromedia Director
Platform Mac/PC

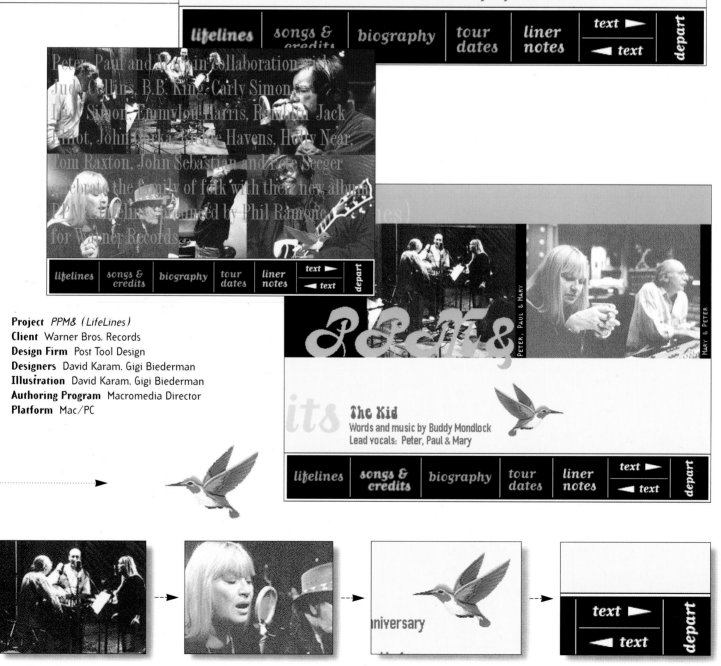

Project Faith No More: *King For A Day/Fool For A Lifetime*
Client Warner Bros. Records
Design Firm Post Tool Design
Designers David Karam, Gigi Biederman
Illustration Eric Drooker "Flood! A Novel in Pictures"
Authoring Program Macromedia Director
Platform Mac/PC

Faith No More's floppy disk-based promotion shows how technical and artistic elements are integral to Post Tool Design's interactive multimedia. In this project, the screens are layered with text and photos, and "graphic novel" style menu buttons at the bottom of every screen serve to unify the presentation. The screens lead the viewer into an interactive playground that cannot be duplicated in any other medium. One screen is filled with pieces of art, text, and photos, which the viewer clears away by clicking on each piece in a "cleansing" process; another is blank until the viewer selects an image to draw with, creating his or her own ephemeral art.

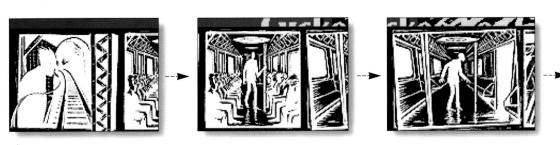